IMAGES OF WAR

THE CRUSHING OF POLAND

RARE PHOTOGRAPHS FROM WARTIME ARCHIVES

IAN BAXTER

Pen & Sword
MILITARY

First published in Great Britain in 2009 by
PEN & SWORD MILITARY
an imprint of
Pen & Sword Books Ltd,
47 Church Street, Barnsley,
South Yorkshire
S70 2AS

ISBN 978-1-84415-846-1

A CIP catalogue record for this book is available
from the British Library.

Printed and bound in Great Britain by CPI UK

Pen & Sword Books Ltd incorporates the imprints of
Pen & Sword Aviation, Pen & Sword Maritime,
Pen & Sword Military, Pen & Sword Select, Pen & Sword Military Classics,
Leo Cooper and Wharncliffe Local History.

For a complete list of Pen & Sword titles please contact:
PEN & SWORD BOOKS LIMITED
47 Church Street, Barnsley, South Yorkshire, S70 2AS, England.
E-mail: enquiries@pen-and-sword.co.uk
Website: www.pen-and-sword.co.uk

Contents

The Author

Ian Baxter is a military historian who specialises in German twentieth century military history. He has written more than twenty books including *'Wolf' Hitler's Wartime Headquarters, Poland – The Eighteen Day Victory March, Panzers In North Africa, The Ardennes Offensive, The Western Campaign, The 12th SS Panzer-Division Hitlerjugend, The Waffen-SS on the Western Front, The Waffen-SS on the Eastern Front, The Red Army At Stalingrad, Elite German Forces of World War II, Armoured Warfare, German Tanks of War, Blitzkrieg, Panzer-Divisions At War, Hitler's Panzers, German Armoured Vehicles of World War Two, Last Two Years of the Waffen-SS At War, German Soldier Uniforms and Insignia, German Guns of the Third Reich, Defeat to Retreat: The Last Years of the German Army At War 1943–1945, Operation Bagration – the destruction of Army Group Centre, German Guns of the Third Reich, Rommel and the Afrika Korps, the Sixth Army and the Road to Stalingrad, U-Boat War*, and most recently, *Hitler's Eastern Front Headquarters 'Wolf's Lair' 1941–1945*. He has written over one hundred journals including *Last days of Hitler, Wolf's Lair, Story of the V1 and V2 rocket programme, Secret Aircraft of World War Two, Rommel At Tobruk, Hitler's War With His Generals, Secret British Plans To Assassinate Hitler, SS At Arnhem, Hitlerjugend, Battle Of Caen 1944, Gebirgsjäger At War, Panzer Crews, Hitlerjugend Guerrillas, Last Battles in the East, Battle of Berlin*, and many more. He has also reviewed numerous military studies for publication, supplied thousands of photographs and important documents to various publishers and film production companies worldwide, and lectures to various schools, colleges and universities throughout the United Kingdom and Southern Ireland.

Acknowledgements

I t is with the greatest pleasure that I use this opportunity on concluding this book to thank those who helped make this volume possible. My expression of gratitude first goes to my German photographic collector Rolf Halfen. He has been an unfailing source; supplying me with a number of photographs that were obtained from numerous private sources. Throughout the research stage of this book Rolf searched and contacted numerous collectors all over Germany, trying in vain to find a multitude of interesting and rare photographs. I am also indebted to Jim Payne who provided me with photos from an album that once belonged to someone who was part of the support staff for General Rommel.

Further afield in the USA I am also extremely grateful to Richard White, who supplied me with a number of photographs that he sought from private photographic collections in Germany and other parts of the world.

Preparation for War

Now that the stage for aggression was set, all military preparations for the planned attack against Poland, code-named 'Case White' (Falls Weiss), was issued to the armed forces. As the second half of August 1939 began, German military chiefs pushed forward their final plans to destroy Poland and liberate its western parts from an area that was predominantly German. On 22 August Hitler summoned his principle Eastern Front commanders to the Obersalzberg and elaborated on his military plans. Speaking with eagerness he told his generals that the war with Poland would be a different type of warfare, not like the dehumanizing years of trench warfare in the 1914–1918 war, but a new concept: Blitzkrieg, a swift all-out attack of such force and ferocity that victory would be secured quickly and decisively.

As a storm began to brew outside he told his captivated audience that they should display an iron nerve, even if the West wanted war, 'it was vital', he said, 'to crush every living spark out of Poland rapidly and, if needed, brutally'. In one of his most arrogant and uncompromising moods he concluded, 'I have done my duty, now go out and do yours'. Commander-in-Chief of the Army, General Walther von Brauchitsch assured his Führer the Wehrmacht would do its duty. He then leaped to his feet and dismissed the whole audience telling them, 'Gentlemen to your stations'.

A few days later as the war clouds of war settled over Europe on the evening of 31 August 1939, a million and a half German troops began moving forward to their final positions on the Polish border for the jump off at dawn. Long columns of vehicles, guns, and men moved forward towards their assembly areas. Thousands of soldiers joined with other columns until the whole German army formed a continuous line of military might. The entire German/Polish frontier had become a vast military encampment. Under the trees beside roads stood dump after dump of artillery ammunition, mines and engineering stores. The soldiers were dwarfed by the tank and vehicles parked hidden in the woods and fields, where trucks and half-tracks, armoured cars and artillery pieces stood in ranks reaching to the horizon. Above all, there were the men – 52 German divisions, corps troops, headquarter units, lines of communication personnel. At last, they were preparing in earnest for what they had to do. Most men were impatient to end the months of training and begin the battle upon which all their thoughts had been focused for so long.

Already the postponement of the attack on 26 August 1939 much increased the mental strain and physical pressure on the men waiting in the fields, undergrowth and forests. They chatted quietly, played cards, and in many cases simply laid in anxious silence.

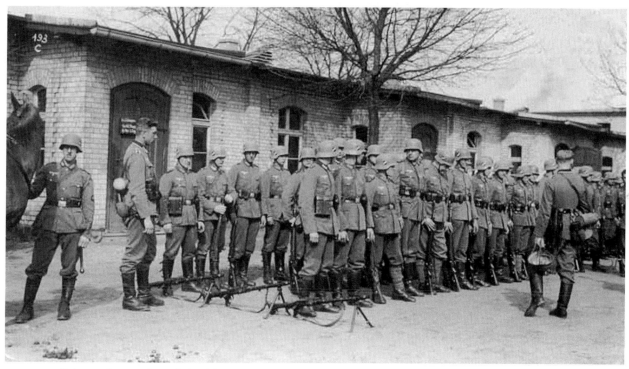

Prior to the attack on Poland in August 1939 German troops line-up for inspection with their rifles. Three MG34 machine guns can be seen on their bipods. Hitler wanted his forces to invade Poland on the 26 August 1939, which was the anniversary of the World War One Battle of Tannenberg, East Prussia in 1914.

As night fell, units which were to form the first line of attack drew up to the frontier area, vehicle headlights were extinguished, smoking forbidden and the formations took up primary positions in the surrounding forests. Nearby the assault detachments moved up to the frontier wire and waited with anxiety at their jumping-off points. As the German Army completed its battle positions there was a general feeling, not of the excitement at the coming of the war, but something more deeply ingrained – a determination and firm belief to do its duty.

Thus as the last steps towards war were inaugurated, Hitler painted the finishing touches to what he called his war of 'liberation'. The well prepared simulated Polish attacks at Pitschen and the principle one at Gleiwitz, remained the only concocting deed that Hitler had left to prove that not Germany, but Poland had fired the first shots of the war.

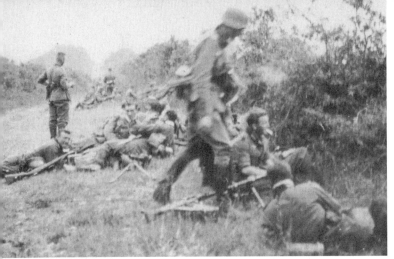

German troops on manoeuvres prior to the invasion. In order to secure secrecy and safeguard a surprise attack, German troop activity in the vicinity of the Polish frontier were called up on the pretext of autumn manoeuvres and by the celebration of the 25th Anniversary of the Battle of Tannenberg.

German naval staff watch as a Pz.Kpfw.IV tank is about to be transported by rail to East Prussia for manoeuvres in August 1939. All troop deployment in Poland was to be completed in 12 weeks before the date for X-Day, 25 August. Its accomplishment remains one of the greatest organisational achievements of the Second World War.

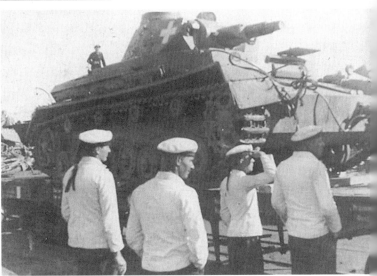

A Pz.Kpfw.I tank is being prepared for transportation during manoeuvres in Poland in August 1939. On a peace footing Germany's armoured strength consisted of five armoured motorised divisions, four motorised divisions and four light divisions. An armoured division was made up of 345 heavy and medium tanks and a light division was half that amount. It was these armoured machines that were going to lead the first lightening strikes into Poland.

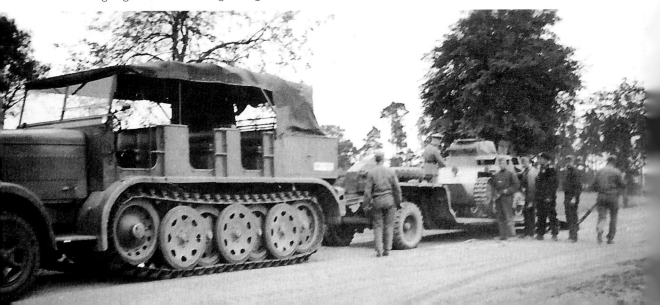

Two soldiers pose for the camera next to their car during the build-up of forces along the Polish frontier in August 1939. The first troop movements to the east actually began in late June, involving a number of infantry divisions.

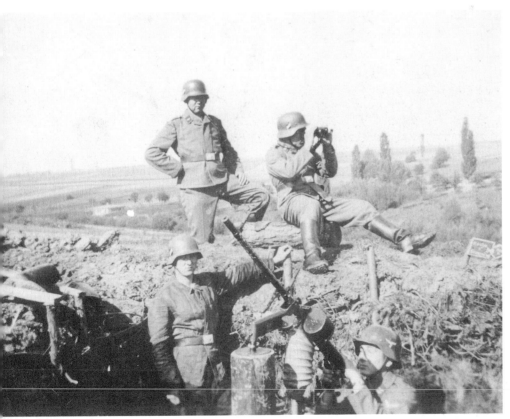

An MG34 machine gun position can be seen dug-in not far from the Polish border in August 1939. During the mobilisation of German forces to the east some units that were dispatched to the frontier regions were actually returned to their home bases before arriving at their command areas, allaying Polish fears of an imminent German attack.

A German soldier on a field telephone. By early August German troops were deployed along the eastern parts of East Prussia. These precautions were to forestall a possible Polish attack on the Reich's most exposed frontier.

A German field kitchen during manoeuvres. In the field assembly areas great tented encampments where created with water points, field bakeries, field kitchens, bath facilities, each one camouflaged with the intent of making it indistinguishable from the air.

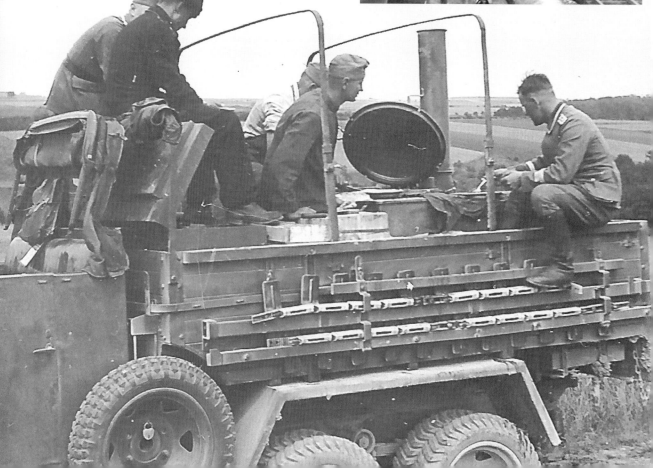

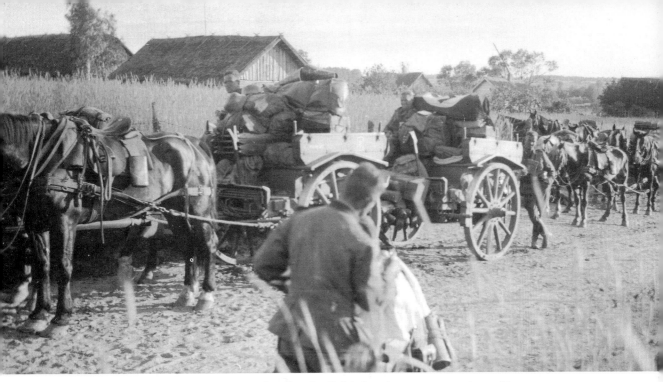

Troops with their horses towing supplies. For the Polish invasion a great number of horses were utilised for towing supplies to the forward edge of the battlefield. Note the national flag draped over the limber carrying supplies. This was done for aerial recognition. During the invasion German forces moved so rapidly east that is was often difficult for air crews to distinguish from friend or foe.

A long column of Pz.Kpfw.IVs on a typical road not far from the Polish border in August 1939. The Panzer divisions had become the modern cavalry of the German Army. The armoured strike was equipped to accomplish a heavy surprise blow at the enemy and gain the spearhead of a tank attack.

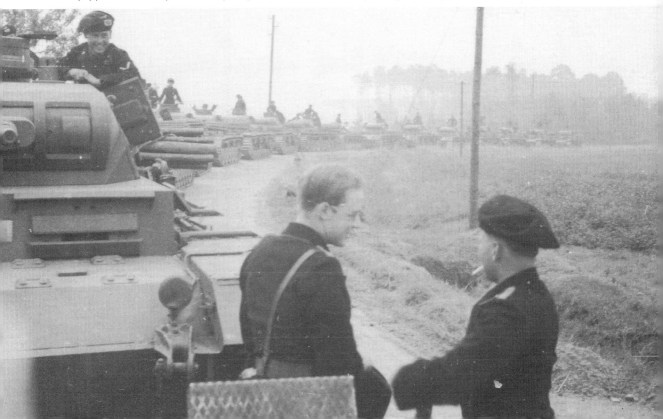

Three Pz.Kpfw.IIs are seen here on manoeuvres just prior to the invasion. Note the white crosses painted on the turrets for ground and aerial recognition. Each Panzer division had a tank brigade totalling some 324 tanks of Pz.Kpfw.Is through to Pz.Kpfw.IV types.

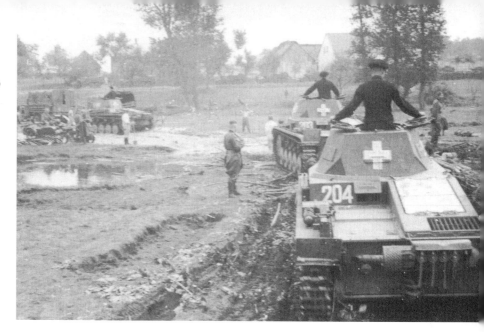

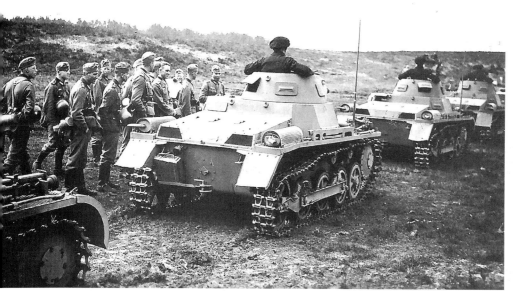

A column of Pz.Kpfw.Is halt in a field during manoeuvres in August 1939. Although the Pz.Kpfw.I was underarmed and underpowered it was more than capable of combating Polish armoured vehicles.

A typical scene prior to the invasion of Poland in August 1939. A multitude of vehicles and Pz.Kpfw.IIs can be seen parked, preparing to move off at a moment's notice. On 23 August Hitler finally made his decision to set 26 August as Y-Day (Invasion Day). The German High Command sent out a code word 'Assume Command', setting German forces to operational duties.

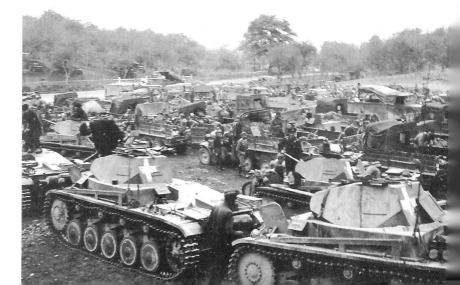

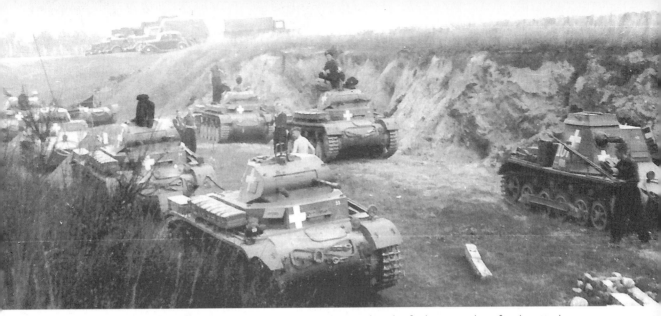

Pz.Kpfw.IIs and Pz.Kpfw.Is wait anxiously in a field as they undertake final preparations for the attack. Everything seemed to confirm that the war would come in the ensuing hours. However, by the early evening of 25 August the troops received a halt order. By a feat of organisation, and despite a ban on wireless traffic, most of the five German Army groups were notified that the attack on Poland had been postponed.

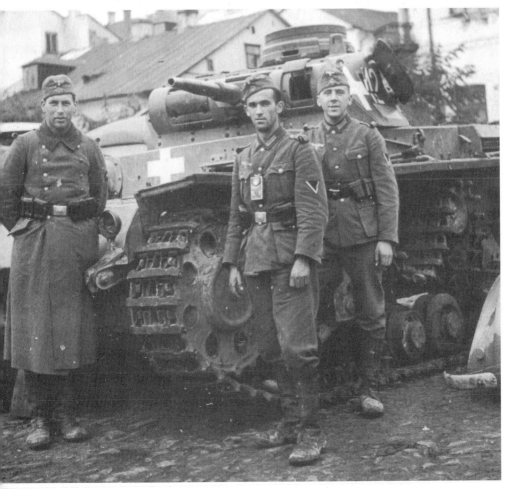

Three soldiers pose for the camera standing next to a Pz.Kpfw.III. After the halt order troops which had been placed in their final deployment areas during the latter part of the troop build-up were needlessly identified by Polish reconnaissance.

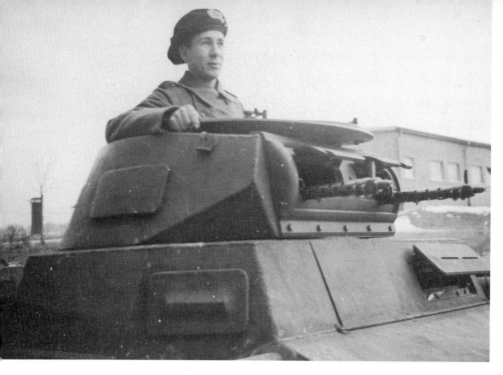

A nice photograph showing a Panzer man in the turret of his Pz.Kpfw.I. Although these tanks were used in relatively large numbers against lightly armed opponents it suffered from very thin armour and an inadequate main gun.

Motorcyclists with their motorcycle combination onboard a flatbed railway car destined for the Polish border in late August 1939. Just twenty-four hours following the postponement of the invasion, the troops received a new zero hour. The new attack was to be unleashed on 1 September 1939.

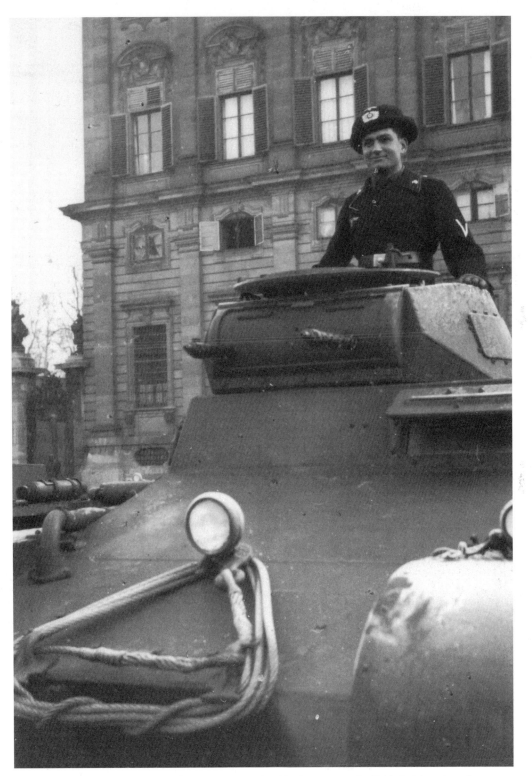

A posed photograph showing a Panzer man perched in the turret of a Pz.Kpfw.I. In spite of these tanks being used extensively during the invasion it was soon obvious that the light tank did not have any combat potential. It suffered from an underpowered engine, uncompetitive armament and was prone to heavy damage from anti-tank shells because of its thin armoured plating.

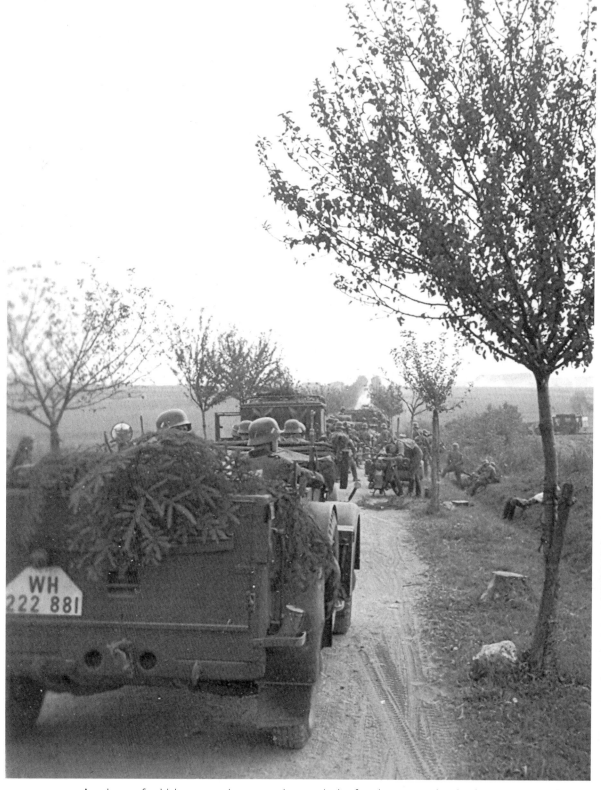

A column of vehicles move along a road towards the frontier area and to begin preparations for the attack on Poland. Note the foliage the crew have draped over parts of the vehicle. This was undertaken in order to camouflage the vehicle and break up its distinctive shape from the air.

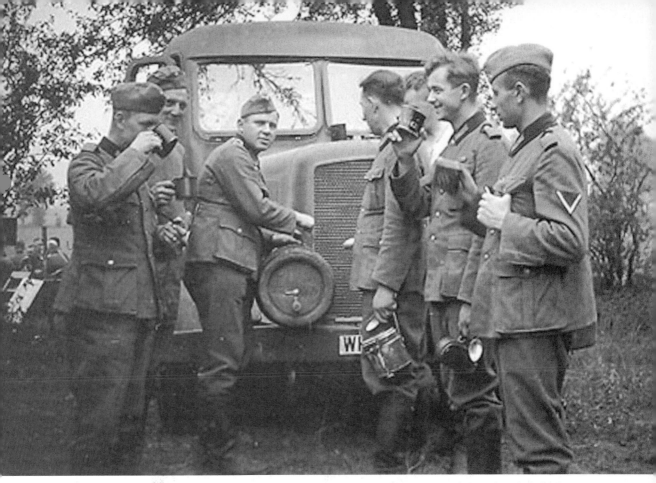

Soldiers laugh and joke among themselves as they wait for the order to move forward to their final `jump-off` positions. In the vicinity of these frontier areas, man, horse and machine were now the most prominent feature. Troop trains were drawn up in the countryside, army vehicles were flooding to the west, building up the frontier defence units.

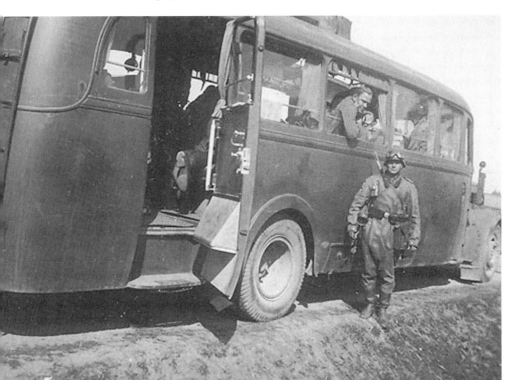

A German motorcyclist in his leather motorcycle coat poses in front of a bus, which has more than likely been utilised to carry troops to the border.

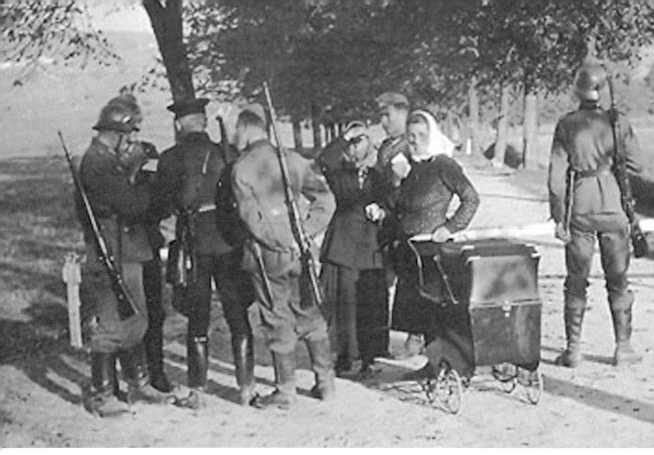

An interesting photograph showing border control police and German troops with Polish peasant women just days before the attack. During this period intensive German preparations for the invasion were so great that German military movements were spotted by Polish civilians along the border areas with Poland.

Four soldiers in a vehicle pose for the camera. Just twenty-four hours prior to the invasion all along the frontier area long columns of vehicles, guns and men moved forward towards their assembly areas.

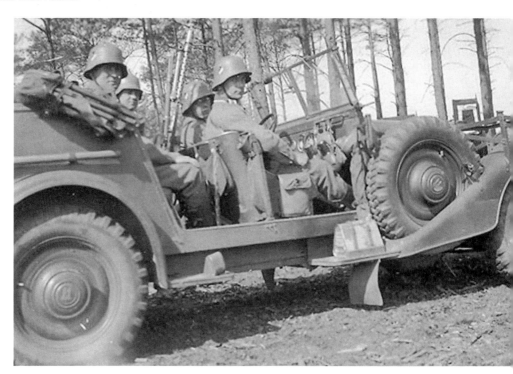

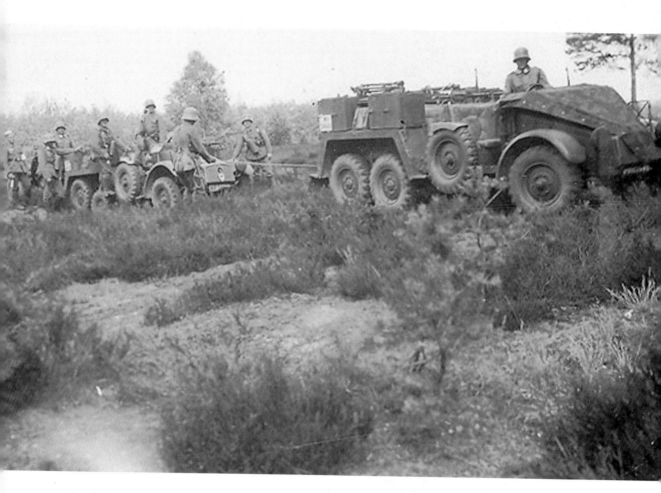

A vehicle on tow across uneven terrain along the Polish border at the end of August 1939. Already the postponement of the attack much increased the mental strain and physical pressure on the men waiting in the fields, undergrowth and forests.

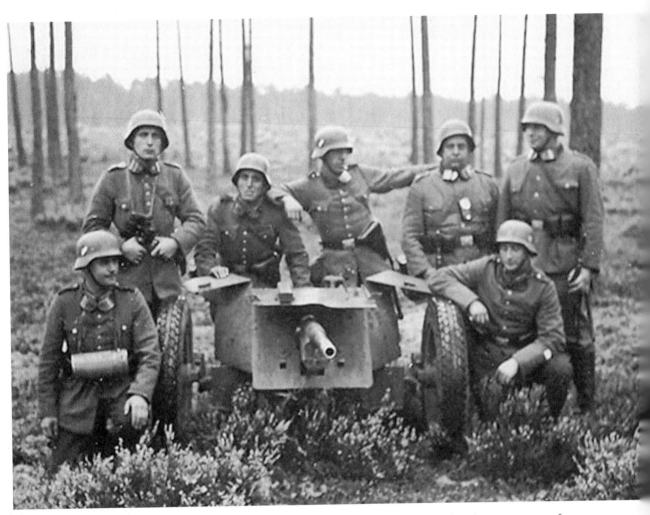

A last photograph before moving to the assembly area. Here German anti-tank gunners pose for the camera next to their Pak35/36 gun. It was in Poland that anti-tank crews found that their PaK guns were more than adequate for operational needs in the face of relatively modest armoured opposition.

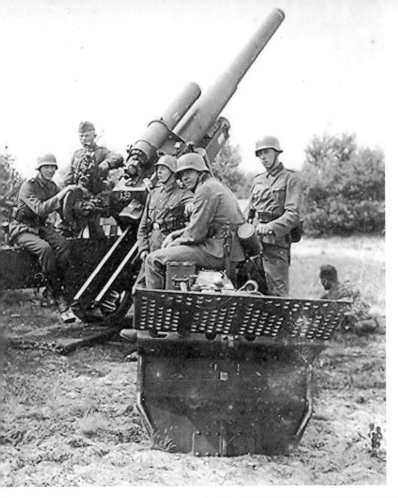

A 15cm artillery crew poised for action along the Polish border. The artillery piece is in an elevated position and is being prepared for war. The power of these heavy field guns could hurl its destructive charge miles into the enemy lines, sometimes with devastating results.

An 8.8cm flak crew enjoying the warm August sun on their backs as they prepare their weapon for action prior to the attack on Poland. The crew have dismounted the limber and can be seen next to the flak gun. Loaded on the halftrack in the rear side storage bin is some of the flak gun's ammunition.

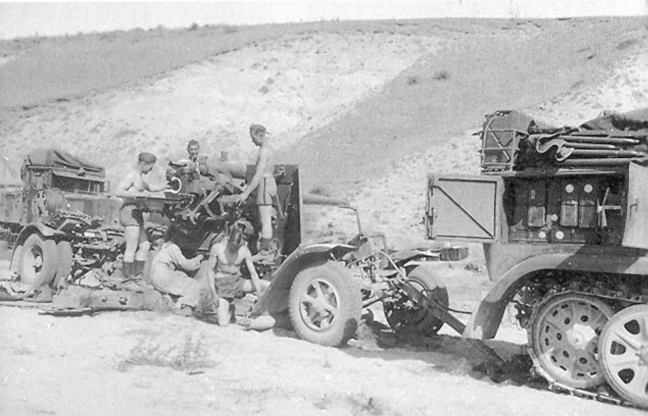

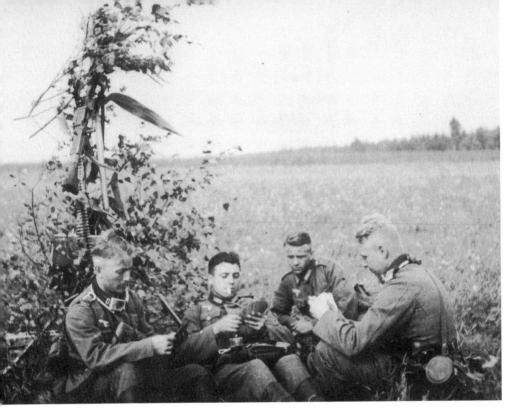

An MG34 machine gun crew relax before being ordered to their final assembly area. Note the heavily camouflaged MG34 machine-gun perched precariously in a small tree. The waiting for the troops was often monotonous and broken only by card games or chatting and joking with their comrades.

Polish troops are guarding a railway bridge over a river just prior to the invasion. When the Luftwaffe opened up the attack on Poland during the early hours of 1 September 1939, aircrews were ordered to attack and destroy all lines of support and communication, which included railway lines and bridges.

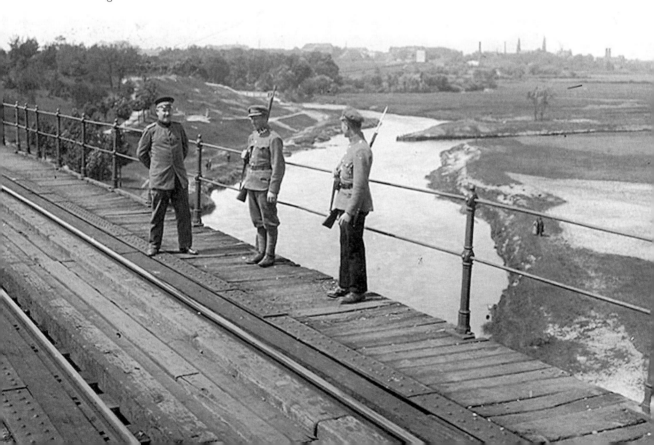

Chapter One

Invasion

During the early hours of 1 September 1939, Hitler's other undercover operations pulled together by a special Abwehr army and Security Service (Sicherheitsdienst) or SD volunteers, infiltrated Poland about 3 a.m. to seize vital bridges, railway junctions, coalmines, and factories. In many places the operations run into stiff resistance. Two strategically important bridges over the river Vistula which were assigned by the Germans to capture intact were blown by the Poles, jeopardising the whole plan which Hitler had specifically ordered in his Directive No.1. To make matters worse early morning fog hampered the dropping of paratroopers, and in some areas the Luftwaffe were grounded altogether by the bad visibility.

At 4.25 a.m. as German soldiers waited anxiously along the frontier, German aircraft began leaving their home bases for Poland. From all their assigned airfields, just five minutes before 'zero-hour', the Luftwaffe began attacking Polish targets. Airfields, aviation production centres, troop concentrations, ammunition dumps, railways, bridges, and open cities were all bombed. Within minutes German warplanes were giving the Poles the first taste of sudden death and destruction from the skies ever experienced on any great scale on earth. In a cauldron of fire Polish soldiers defending the front lines were unable to combat these incessant aerial bombings and were annihilated or torn to pieces by the dive bombers.

As the Luftwaffe endlessly roared above, on the ground German soldiers had been using nothing more than artillery fire as cover. For nearly an hour an eruption of artillery burst along the German/Polish front. When the barrage subsided, the avalanche broke. An army of formidable tanks juggernauted swiftly across the Polish frontier into the Polish heartlands to achieve its first tactical bounds.

Now in an instant German soldiers were moved forward into action. Their path was forced open principally by tanks that rammed and overrun obstacles by accident or intent. The Poles it seemed, were simply overwhelmed by the German onslaught. The sudden surprise attack; the bombers and fighter planes soaring overhead, reconnoitring, attacking, spreading fire and fear; the Stukas howling as they dived; the tanks, whole divisions of them breaking across even the most rutty Polish roads; the amazing speed of the infantry, of the whole huge army of a million and a half men on horses, motorised wheels, directed and co-ordinated through a

complicated maze of electronic communications of intricate radio, telephone and telegraphic networks. This was a monstrous mechanised juggernaut such as the earth had never seen.

To carry out this monumental task against Poland there were two Army Groups – Army Group North, consisting of the Fourth and Third armies, under the command of General Fedor von Bock, and the Southern Army Group, consisting of the Eighth, Tenth and Fourteenth armies, commanded by General Gerd von Rundstedt. From north to south all five German Army Groups crashed over the frontier. Almost immediately they quickly began achieving their objectives.

All along the German front shells and mortars rained down on the defenders as they cowered at the bottom of their foxholes and trenches. Panzers, many of them, came in large groups, clattering forward in low gear, their machine guns chattering to keep the Poles' heads down. Everywhere the German probed the defence looking for weak spots. Successfully they infiltrated everywhere making a determined attempt to cut off the defender's rear. In most cases Polish soldiers were forced to withdraw by overwhelming strength. Some Poles, however, even though their positions seemed to be like little oases of defended terrain, preferred to fight to the bitter end.

Spearheading one of the first promising attacks into Poland from the north was General Gunther Hans von Kluge's Fourth Army. Kluge controlled five infantry divisions, plus two motorised divisions and the Third Panzer Division under General Heinz Guderian. The main thrust of the Fourth Army was east and south, sealing off and then destroying General Bortnowski's Pomorze Army, which was situated in

Tanks finally roll forward into action during the early morning of 1 September 1939. Here Pz.Kpfw.IIs advance across a field with infantry moving closely behind for cover. A Pz.Kpfw.IV can be seen at the front of the tank attack. In the distance black plumes of smoke can be seen rising into the air, indicating heavy contact with the enemy.

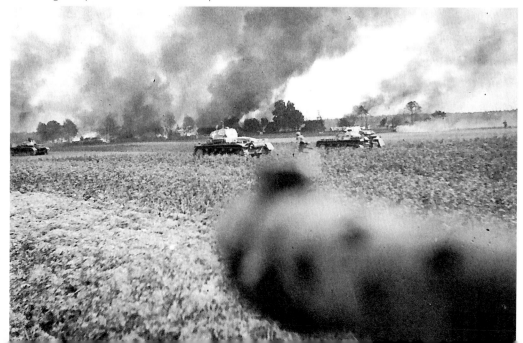

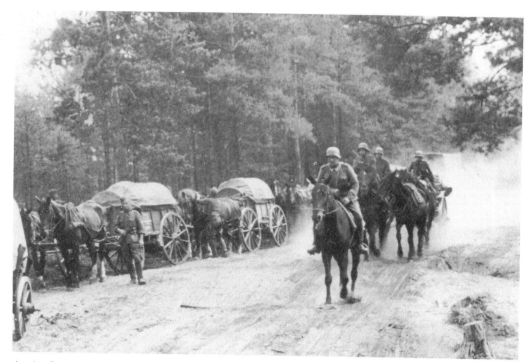

As the Panzers spearheaded into action supplies were desperately required to keep up with the fast pace of the invasion. Here horse drawn supplies hastily move forward along a dusty dirt track.

what was known as the Polish corridor. All main efforts were carried out by the army's XIX Corps, under the faithful command of the Panzer ace, General Heinz Guderian. Bearing the brunt of this German armoured stampede stood the Pomorze Army, which consisted of five infantry divisions and one cavalry brigade. Throughout the first day of intensive fighting Kluge's army caused such severe losses to the Pomorze Army that it was forced to reluctantly withdraw in total confusion.

Further east, separated by the Polish corridor in East Prussia, General George von Kuechler's Third Army made a number of thrusting all-out attacks south from the Prussian border in the direction of Warsaw against the Polish Narew Group and Modlin Army. Under Kuechler's command advanced seven infantry divisions, an ad hoc panzer division consisting of SS-Panzer Division 'Kempf', which incorporated SS-Panzer Regiment Deutschland, and four brigade-size commands, which were all divided under three corps.

During the course of the first day five of Kuechler's infantry divisions and the SS-Panzer Division 'Kempf', nicknamed by its troops as 'Division-Kempf', advanced south at breakneck speed until they smashed head-long into a number of well fortified positions around the area of Mlawa. Immediately 'Division-Kempf', which had been leading the furious drive south, was given the task to destroy the

permanent fortification which consisted of a number of heavy fortified pillboxes. For the next few days, 'Kempf', supported by divisional artillery, became increasingly embroiled in a number of savage engagements until it finally surrendered.

To the south German forces were inflicting almost equal misery upon the enemy. Army Group South's main task was to try and engage the enemy as far forward of the Vistula and eliminate any attempt he might make to retreat east behind the line of the Vistula and San. It was for this reason that the Southern Army Group were ordered to reach the Vistula and San with the greatest possible speed.

Throughout 1 September, German soldiers strove to achieve its objectives. Eighth Army, under the command of General Johannes von Blaskowitz, had driven his four infantry divisions successfully forward despite meeting fierce resistance from the Lodz Army. Although most of the roads were often little more than tracks in the predominantly sandy soil, movement, thanks to the particularly hot and sunny weather – baptised, 'Führer weather', went according to plan.

On Eighth Army's southern flank, General Walter von Reichenau's Tenth Army launched a series of infantry attacks through forested areas that run along vast parts of the frontier. Some of these attacks met virtually no opposition as the main Polish defence line was positioned miles from the German border. Von Reichenau's army concentrated two powerful armoured forces, one to the north of the city of Czestochowa, and the other on the south moving on both sides of the town of Lubliniec. In the centre, three infantry divisions covered the central drive. The two armoured units, which were conducting operations on the northern and southern arms was General Reinhardt's 4th Panzer Division, which was the strongest division in the entire German Army. It was given the difficult task of driving at breakneck speed on Warsaw. For most of the day the Tenth Army continued to consume ever increasing pressure on the Lodz Army. With incredible anger the formidable cadre of the German Army, including some of its most skilled and dedicated men achieved remarkable gains with typical military thoroughness. Their reeling advance had taken them head-on into huge retreating enemy formations, and with it came the capture of town after town, village after village. As the Germans gathered momentum the main focus of struggle concentrated upon the main towns where the wreckage of hundreds of Poles from the Lodz Army were fighting for survival. Blackened vehicles, blackened buildings and woods scarred every acre over which the battle had passed.

On Tenth Army's southern flank, General List's Fourteenth Army comprising of some seven infantry and two armoured divisions made staggering advances against the Krakow and Carpathian armies. In just several hours List's troops had catapulted across the frontier and burst onto the Polish heartlands far ahead of schedule. Even in the jagged terrain of the Tatra and Carpathian mountains many army vehicles were rolling freely along the narrow, dusty roads. In endless lines the convoys roared through heading east on the long haul to the Vistula and San rivers.

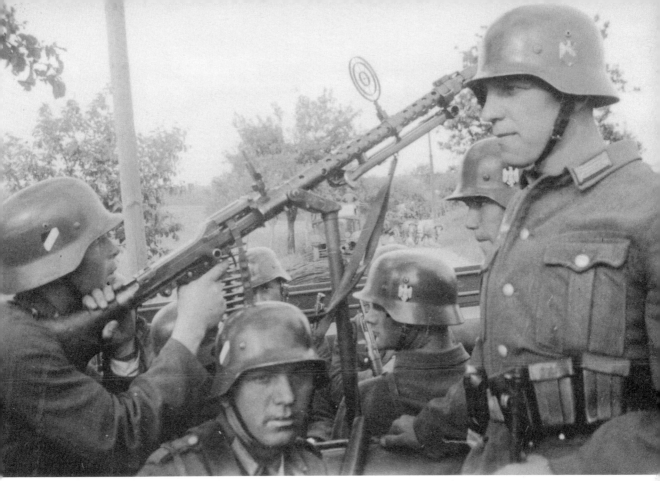

A machine gunner with his MG34 machine gun mounted on a tripod aims skyward as the column of motor vehicles and animal draught push along a very congested road during the first morning of the attack.

The entire thrust of the German Army was quick and swift. The fruits of the dash east were intoxicating for the men riding the tanks and trucks. An almost unopposed advance across country against a disorganised jumble of Polish units retreating with all they could muster had instilled every German soldier with eager enthusiasm. But following this initial excitement of battle, the rapid capture of the first towns and villages, the dramatic seizure of heavy fortified positions, and the clearance of the frontier area, the mood among the men slowly changed, as certain parts of the front stiffened and congealed. They began to quickly learn the costs of conflict. In some areas the Germans found the quality of their opposition extraordinarily uneven. At one moment a handful of them were receiving wholesale enemy surrenders. Whilst in some sectors an entire division found itself being held up by stubborn resistance of a company of Polish troops with a detachment of artillery and anti-tank guns. Yet despite the determination of these brave Polish soldiers, fast and devastatingly efficient Blitzkrieg had arrived.

From the beginning of the invasion the Luftwaffe had paralysed large sections of the Polish railway network, severely disrupting the desperately needed mobilisation, which was still far from completed. Bewildered Polish commanders struggled despairingly to hold their forces together. They were paralysed by developments they had not faintly expected, and could not organise their army in the utter confusion that ensued on the battlefield. In many areas the virtual collapse of the communication system had left many commands isolated, making it difficult for them to establish contact with the fronts. Consequently decisions were almost invariably late and therefore disastrously overtaken by events with the result of one position after another being lost to the Germans. Already the fleeing Polish Army were being mauled almost to death by constant air attacks and pounded mercilessly by tanks and artillery. The Poles were faced with the finest fighting army that the world had ever seen. The quality of the German weapons – above all the Panzers – was of immense importance in Poland. Their tactics were the best; stubborn defence; concentrated local firepower from machine-guns and mortars; rapid counter-attacks to recover lost ground. Units often fought on even when cut-off, which was not a mark of fanaticism, but of masterly tactical discipline. The invasion was a product of dazzling organisation and staff work, and marvellous technical ingenuity. Each operation profited from the mistakes of the last, used mass firepower to wear down the Poles, absorbed disappointments without trauma. Everything it seemed went according to plan, or even better than the plan, in the unfolding both of strategy and tactics. Both Hitler and his Generals were confounded by the lightening speed and the extent of their own gains. As the sun disappeared beyond the scarred remains of Poland that first day in September the die it seemed had already been cast – Germany would soon be reaping the glories of victory.

An MG34 machine gun crew in action against a group of Polish bunkers. For hundreds of miles along the Polish frontier machine guns, mortars, and artillery fired into the Polish lines before the troops were finally sent forward into action, following in the wake of the armoured drive.

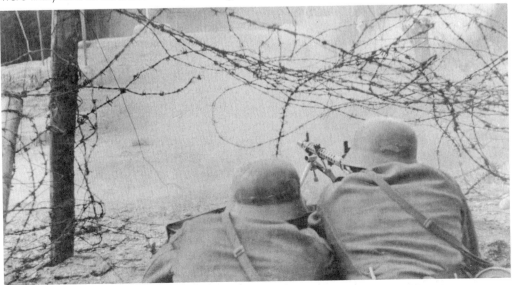

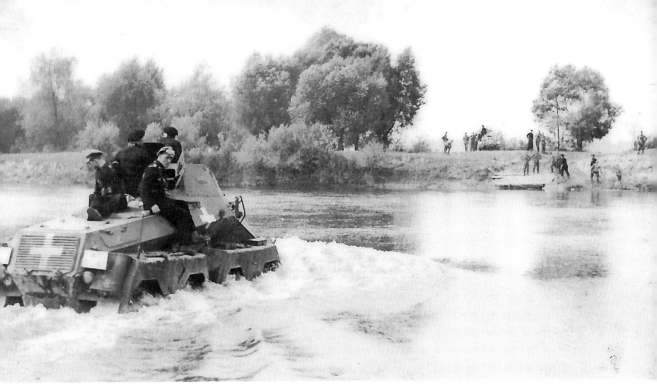

An Sd.Kfz.231 heavy armoured vehicle fords a shallow river. Spearheading the first promising attacks into Poland was the Fourth Army. Polish commanders were surprised to see the Germans driving mechanised units across rivers and dense undergrowth.

Halted on a road is an Sd.Kfz.221. During the first morning of the attack nothing it seemed could with-stand this German stampede of vehicles and armour. In many areas Polish forces were simply brushed aside, thrown in complete confusion.

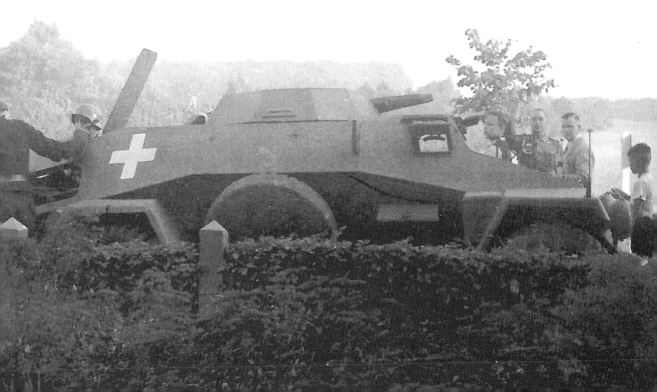

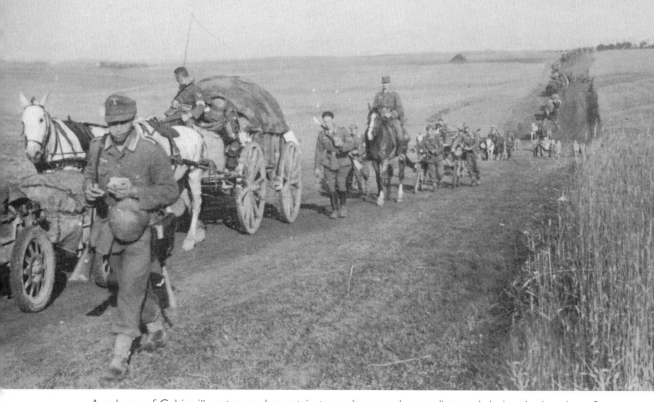

A column of Gebirgsjäger troops (mountain troops) move along a dirt road during the invasion of Poland. The 2nd Gebirgsjäger Division fought as part of Army Group South in southern Poland and took part in the march to capture the city of Lemberg.

A halftrack towing a 15cm howitzer after a heavy downpour of rain. During the Polish campaign the weather was particularly favourable to the German forces and they baptized it 'Führer Weather'. If the German High Command had postponed the invasion any longer they feared that bad weather would turn the roads into a quagmire and bring the advance to a crawl.

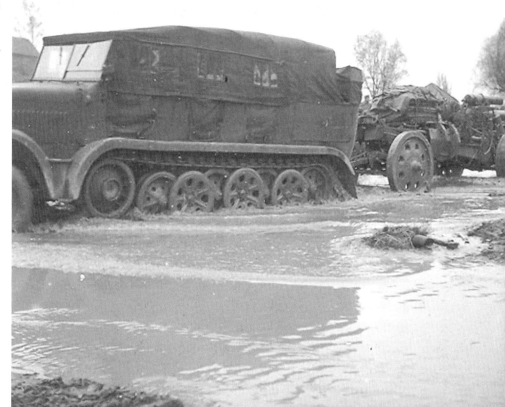

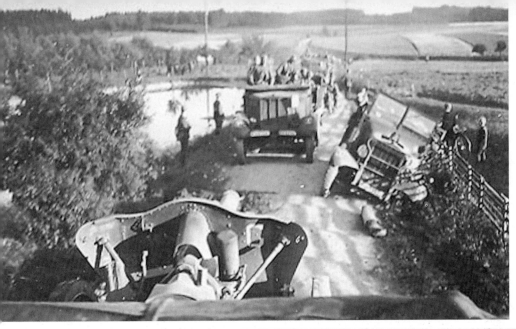

A column of halftracks towing what appears to be 10.5cm artillery pieces along a congested road. One vehicle has come off the road and has become stuck in the soft soil. Local children in field watch the spectacle.

A line of vehicles and a motorcycle combination move slowly through a newly captured town passing a dead horse that was obviously killed during the intensive fighting. Although the advance on 1 September was going extremely well, the Germans were meeting spirited resistance along the frontier in a number of places.

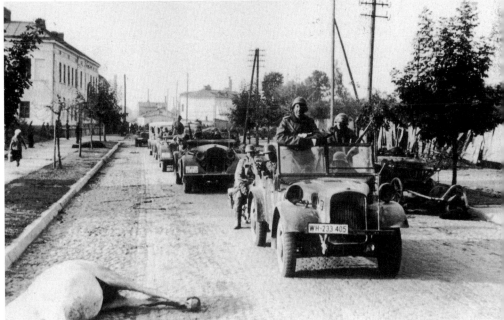

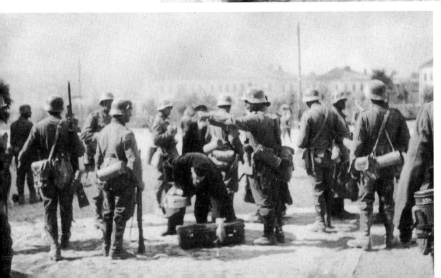

In the same town German infantry can be seen gathering in the town's square. In front of them buildings are set on fire by shelling and Jews are seen rounding up their belongings. For these young soldiers it was their first experience of the East, and the first time they had ever seen Eastern Jews. They had seen these figures in many of the anti-Semitic drawings plastered up on notice boards, walls and lamp-posts throughout Germany.

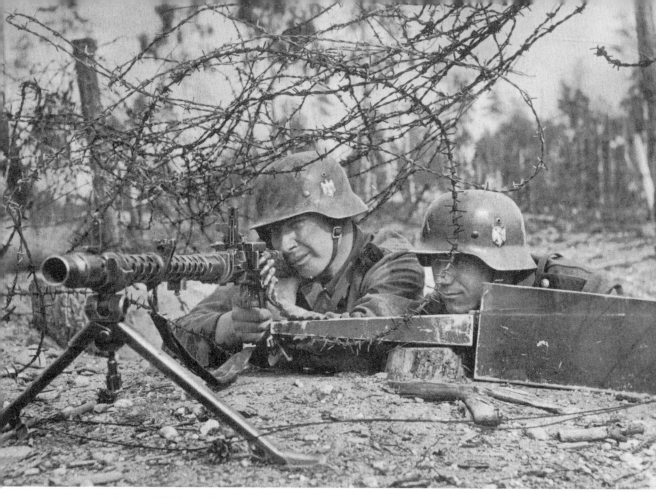

In action an MG34 machine gunner and his feeder have been embroiled in some heavy fighting near a Polish position. The area has obviously been captured and this photograph is a posed shot for the German Press.

German troops belonging to the Fourth Army poised in a field during their furious drive eastwards. Although the Fourth Army`s advance was successful, resistance by the Poles remained fierce. The Polish Pomorze Army which was laying beneath the feet of Fourth Army's advance bore the brunt of every attack. Subsequently, the Poles were compelled to flee under ferocious unceasing fire.

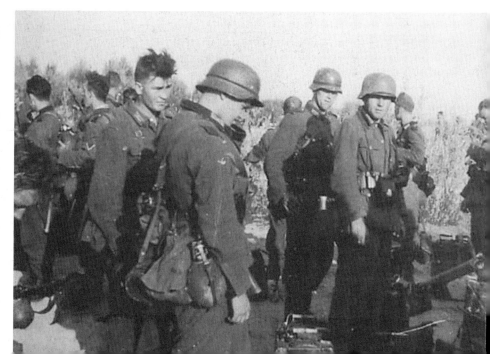

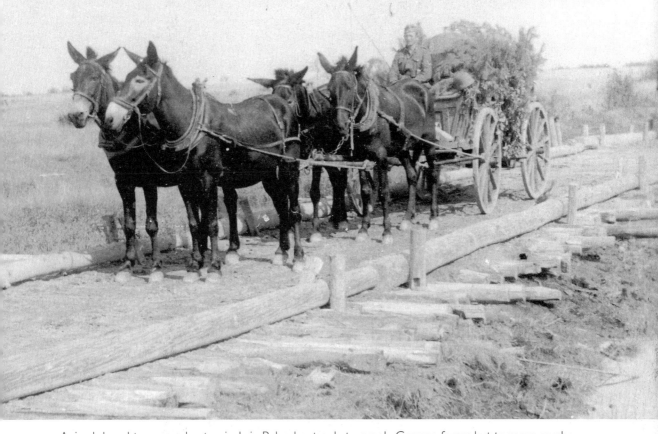

Animal draught was used extensively in Poland not only to supply German forces but to move much of their armour and men to the forward edge of the battlefield. Here in these two photographs horses pull a wagon across a makeshift wooden bridge, destined for the front lines.

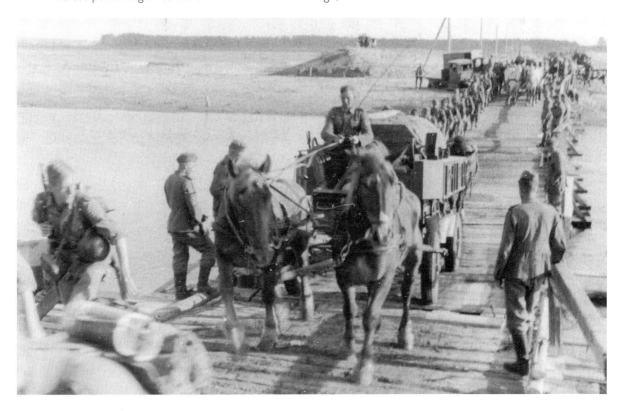

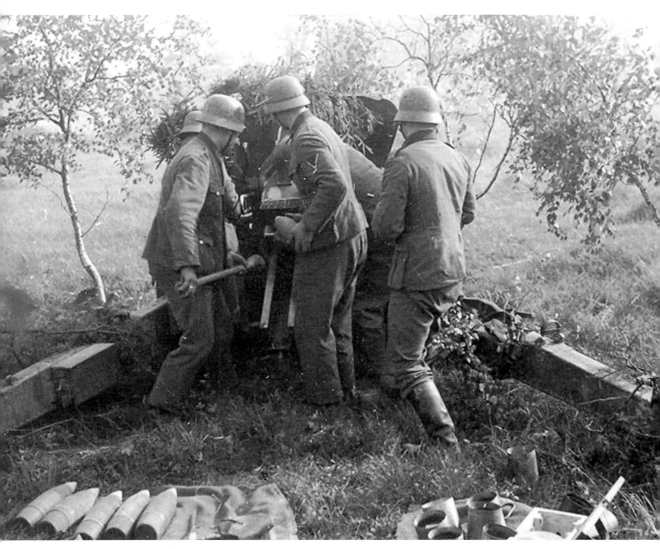

A 10.5cm artillery gun is about to be fired in anger against Polish positions. The bulk of German artillery helped pave the way for Panzers and troops to pour through and advance at breakneck speeds. The Luftwaffe too also helped in the advance by wreaking havoc on the Poles and giving them the first taste of sudden death and destruction from the skies.

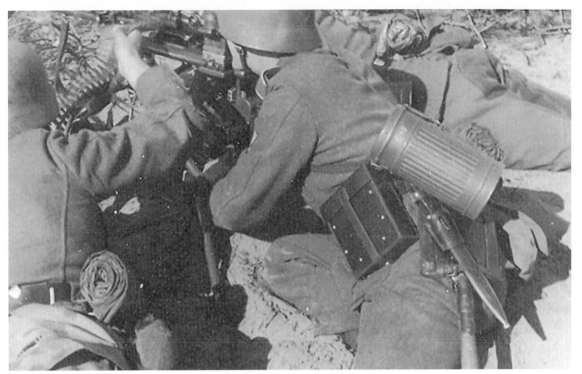

Two photographs taken in sequence showing an MG34 machine gun mounted on a sustained fire mount in action against an enemy position. The MG34 not only had superb offensive capabilities on the battlefield, but impressive defensive ones too. Indeed a couple of well-sighted MG34 machines guns could inflict heavy casualties on an entire attacking regiment and could hold a frontage for several miles.

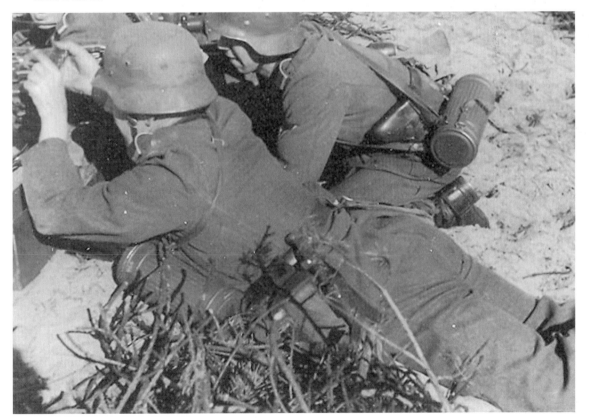

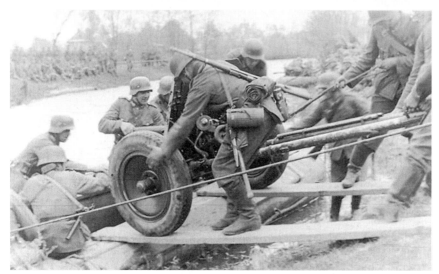

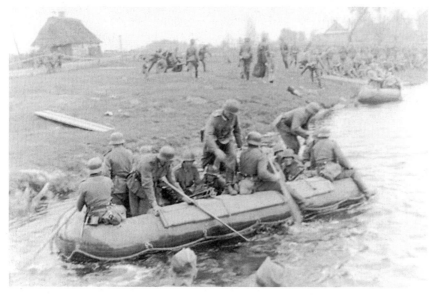

Four photographs showing troops crossing a river in an inflatable boat and manhandling a Pak35/36 anti-tank gun across a small river during the early phase of 'Case White', the code word for the invasion of Poland.

The great majority of German soldiers had never seen action and approached the campaign with an eagerness that promised much to their commanders. The average infantryman had no real urge to kill people, but just wanted to face the challenge of fighting.

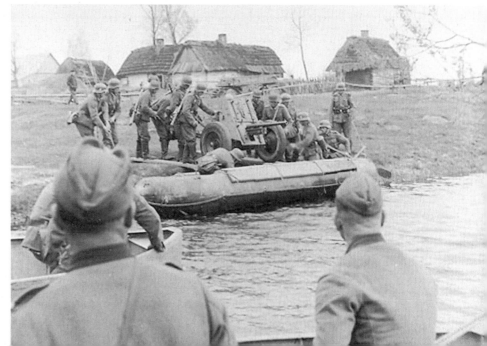

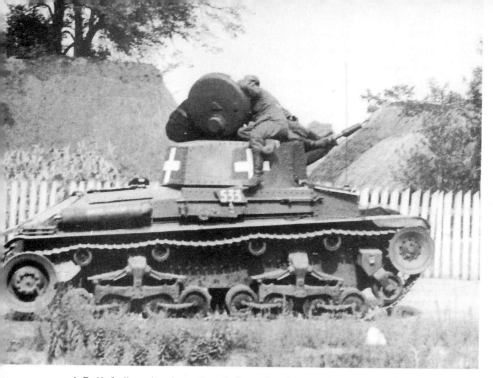

A Pz.Kpfw.35 (t) halted on a road inside a village on the first day of hostilities. Note the white solid cross on the side and rear of this Czech built tank. These white crosses were first ordered to be applied in August 1939. However, once these vehicles reached Poland, vehicle crews soon felt that the crosses were too prominent, and were providing too easy aiming point for Polish anti-tank gunners even at longer than normal ranges.

A Pz.Kpfw.II wades through a shallow river. Note the non-appearance of the solid white cross on the turret sides. According to a German report, up to 25 percent of the total tank losses were due to the highly visible white crosses. The first expedient adopted was simply to camouflage the crosses, and to either use paint or smear mud over the remaining insignia.

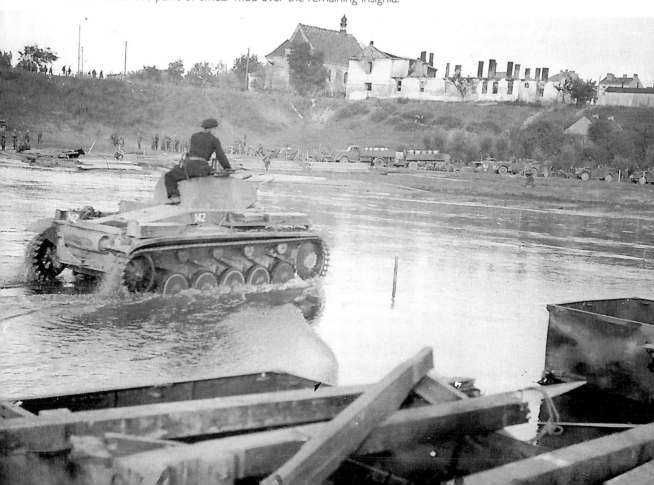

A Pz.Kpfw.III in some undergrowth preparing to move off into action. During the campaign the Polish airforce was almost non-existent, but in some areas aircraft did attack German positions and armoured columns forcing some Panzer commanders to take evasive action by temporarily hiding in undergrowth or forested regions.

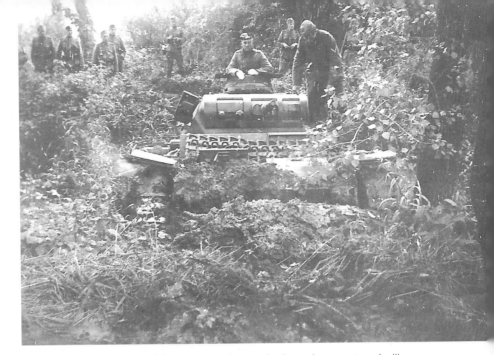

A Pz.Kpfw.II leads a column of armoured vehicles along a dirt track through a captured village. Although this vehicle was underpowered, under-gunned and with thin armoured plating, it was the backbone of the Panzer divisions of the early Blitzkrieg campaigns.

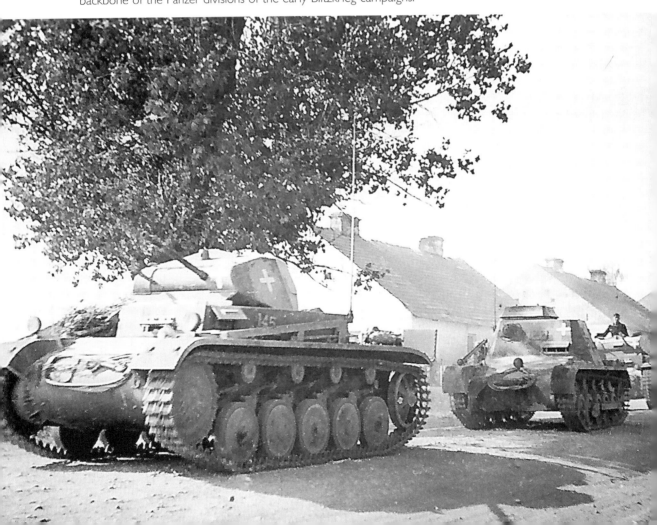

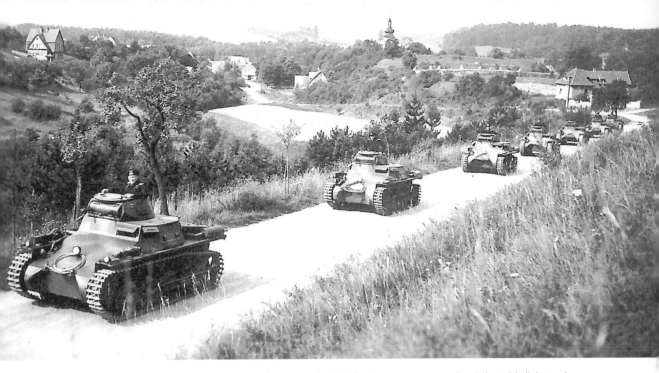

A line of Pz.Kpfw.Is advance along a road eastwards. In Poland crews soon realised that this light tank could not withstand anti-tank fire. Only small calibre weapon's fire and shell fragments would bounce off the 13mm armoured plating. Mines and 2cm shells, however, could easily knock out these vehicles.

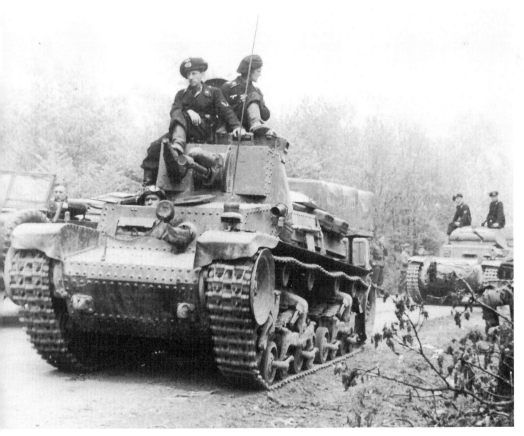

A Pz.Kpfw.35 (t) leads a Pz.Kpfw.II during the furious armoured drive in Poland. Note all the Panzer men are wearing their distinctive black Panzer uniforms and beret. The beret remained in service with the Panzer crews until January 1941.

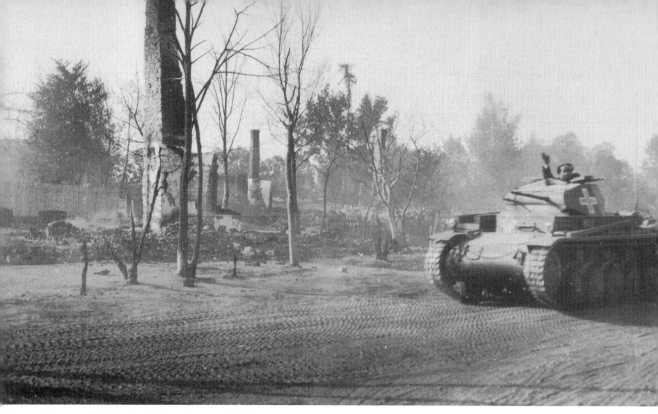

Driving through a devastated village is a Pz.Kpfw.II. The commander waves at the camera as he passes through without stopping. Note the unusual cross painted on the side on the vehicles turret. The white crosses appear to have been erased but carry a white outline.

A Pz.Kpfw.II attached to Eighth Army rolls past stationary Pak35/36 anti-tank gunners. A solider can also be seen resting beside a parked Pz.Kpfw.251 halftrack. On the first day of the attack Eighth Army's advance was constantly being hampered by well dug in enemy positions. Throughout the day bitter confrontation intensified against the Polish Lodz Army.

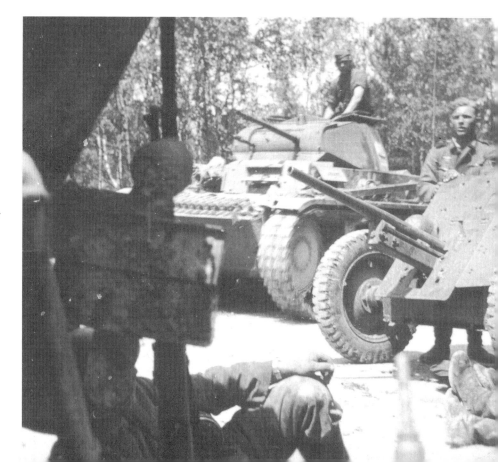

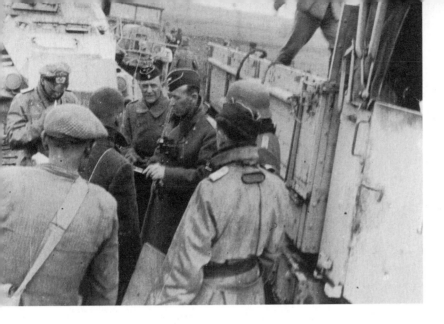

German commanders confer on the next strategic move ahead. Throughout the first day in many areas of the front the German Army achieved remarkable gains. Their reeling advance had taken them head-on into huge retreating enemy formations, and with it came the capture of town after town, village after village.

A German artillery officer raises his arm giving the order for the gunners to fire their 15cm howitzer. Before an armoured attack, artillery crews concentrated on enemy tanks and armoured vehicles in the assembly areas, unleashing their fire power where anti-tank units were suspected to be located. High explosives were also targeted against probable enemy observation posts to blind them with smoke.

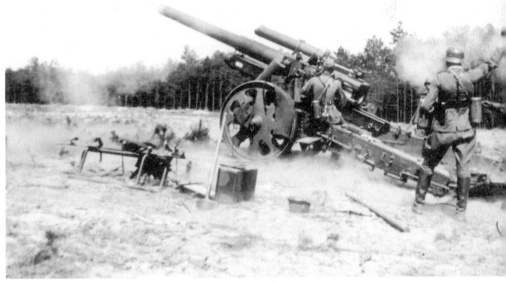

Gebirgsjäger troops of the 2nd Gebirgsjäger Division halt at a river bank after a bridge has been apparently blown by Polish forces. The rapid drive of the Germans meant that many units were constantly being halted, waiting for vital supplies or engineering units to build pontoons.

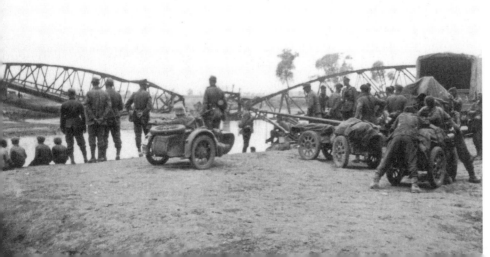

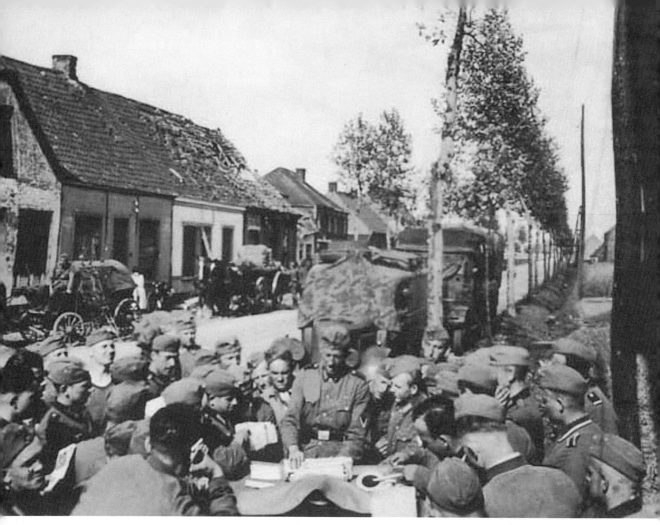

A commander confers with his men inside a recently captured Polish village. Within only a matter of a couple of days German commanders could not mask the absolute German triumph of establishing themselves deep inside enemy held territory. For the bewildered Poles, fast and devastatingly efficient Blitzkrieg had arrived.

German engineers are building a bridge across a river. It was vital that these bridge sections were erected as quickly as possible in order not to hinder the German drive east.

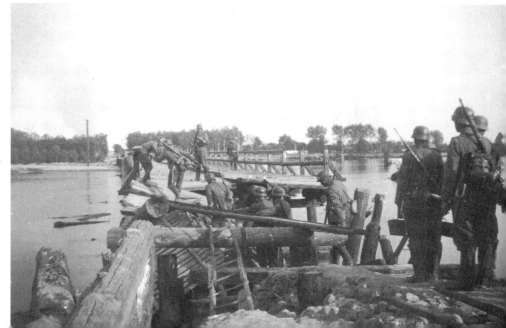

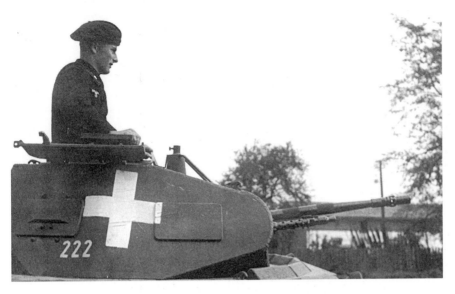

A tank commander sits in the turret of his Pz.Kpfw.II. The white cross can clearly be seen painted on the turret above the white tactical number '222'. During the invasion Panzer crews found that by painting the crosses over – either completely, or leaving a narrow white border – with the deep yellow colour, was one option to reduce the prominence of the large white cross.

A nice photograph showing a Pz.Kpfw.II that has applied some foliage on the engine deck and sides of the vehicle. Note the non-appearance of the white cross on the turret, which has clearly been removed by the crew. Throughout the campaign many units simply had the crosses painted out altogether, while others seem to have retained the full array.

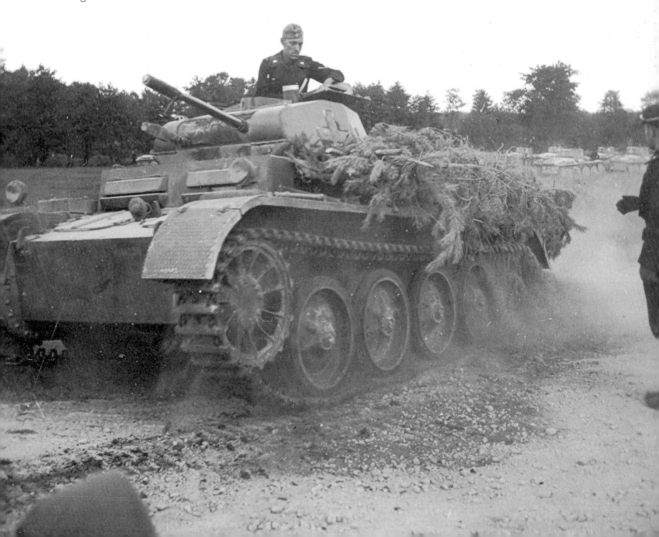

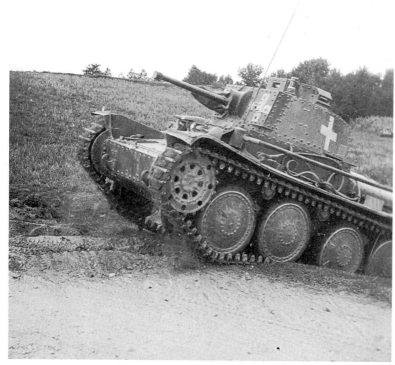

A Pz.Kpfw.38 (t) negotiates a small gradient onto a dirt road. During the Polish invasion there were some 112 Pz.Kpw.38 (t)s that made their debut on the battlefield. Half of these were attached with the 3rd Light Division.

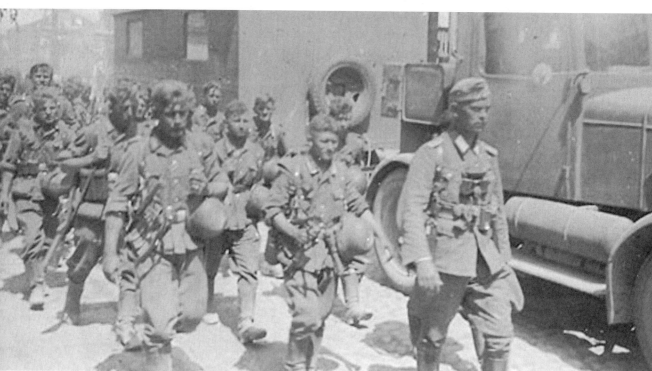

German troops march through a town. Within a few days of the attack there was utter confusion and mayhem on the disintegrating and receding Polish front lines. The Polish difficulties did not just lay with their lack of planning or foresight, but in the difference in fighting ability between the opposing forces on the battlefield.

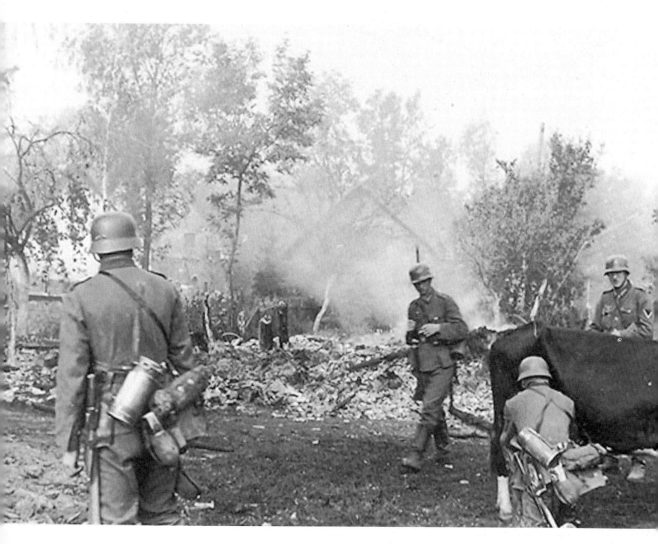

Infantry halt inside a burning village following heavy contact with the enemy. One soldier can be seen milking a cow. Already the fleeing Polish Army were being mauled almost to death by constant air attacks and pounded by artillery.

German soldiers have halted their drive and move their vehicles and men to the edge of the roadside using a forest as local cover. Note the condition of the road. It would only take a heavy downpour of rain and the whole road would turn into a quagmire, making it almost impossible for wheeled vehicles to move.

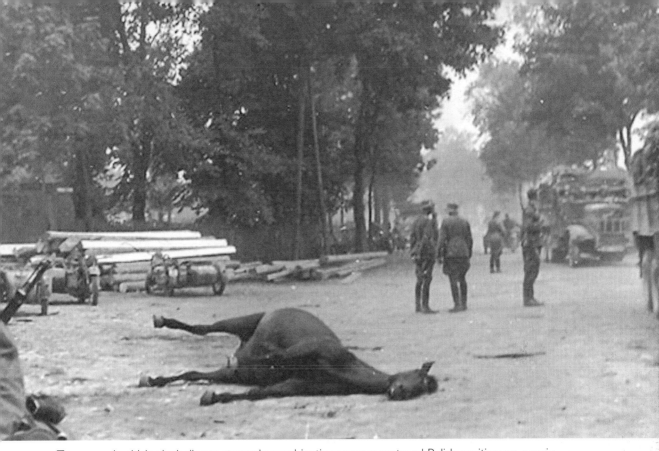

Troops and vehicles including motorcycle combinations pass a captured Polish position on a main road. A dead horse lies on the side of the road as a grim reminder of the heavy fighting in the area. Many thousands of horses on both sides were killed during the invasion.

Not much action for these three 15cm howitzers, which are all in their elevated position. The gun pictured was capable of firing eight different propellant charges, depending on the range and effect of its desired target.

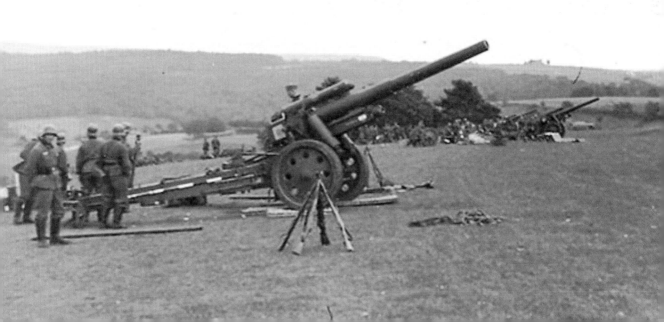

A number of crewman pose for the camera in front of an Sd.Kfz.221 armoured vehicle. Note the motorcyclist on the far right wearing a bandage over his right eye. Motorcyclists were very easily prone getting dust particles and other fragments churned-up from the road surface plastered onto their face. Aviator goggles were invariably worn, but some felt that it restricted visibility, and as a consequence there were casualties.

Chapter Two

Pushing East

Over the next few days both the German Northern and Southern groups continued to make furious thrusts on all fronts. As this great advance gathered momentum, more towns and villages fell to the onrushing forces. The campaign had taken on the character that was to remain for the few weeks that followed. Everywhere north, south and east the fronts were shrinking, cracking slowly but surely under the massive German pressure. In this unparalleled armoured dash, some units had covered 40-60 road miles in just twenty-four hours. For many soldiers it was an exhilarating dash, Panzers bucketing across the countryside, meeting in some places only isolated pockets of resistance.

In just over five days of unbroken combat, Kluge's Fourth Army had cut through the Polish corridor, established a breach between Pomerania and East Prussia, and encircled thousands of enemy soldiers from the Poznan and Pomorze Army. Elements of Guderian's XIX Corps crossed the Vistula and were informed under the direct command of von Bock to transport its tank battalions through East Prussia; thereafter the corps was to effectively concentrate on the left wing of the Third Army. It was to operate close co-ordination with Kuechler's force and move out through Lomza, heading east of Warsaw.

In Third Army, infantry and armoured forces continued to push southwards. Already by September 5 Kuechler's force alone had captured 15,000 prisoners, were driving the Modlin Army back, Panzer Division Kempf had broken through and its spearheads were less than thirty-five miles from Warsaw. Already some forward units were reporting that they had reached strong defensive positions on the Narew river. In the following days to come there would be thousands of German troops crossing the river, hurling themselves east of Warsaw.

South of the country operations were moving as rapidly as those in the north. Both the Eighth and Tenth armies especially fought a measured, stage by stage battle in which the enemy retreated to fresh defensive positions as their lines were driven in by successive German attacks. The bulk of Blaskowitz's Eighth Army maintained a steady drive on the city of Lodz. But constantly units found themselves confounded by the appalling traffic jams clogging the advance by refugees, and by the Polish army vehicles entangled upon the roads that had been endlessly strafed by air-attack. Most

Two photographs showing exhausted soldiers taking a much needed respite during the army's rapid advance east. Never-ending foot marches were very common during the campaign and as result many soldiers suffered by fatigue, especially during the day with the warm weather.

vehicles, particularly the Panzers, struck off across country to escape the chaos and continued their unopposed dash.

In Tenth Army, armour of formidable size and anger made a number of deep penetrating thrusts. Only on the roads did the traffic slow; the deep dust billowing above the columns, choking men and horses, and sifting into motors. All along Reichenau's front unceasing attacks embraced the dwindling enemy lines. For striking power the Tenth Army relied on its tremendous superiority in tanks and artillery. By 6 September Reichenau boasted that his front stretched south from Lodz to within sixty miles north of Krakow. His armoured dash was now threatening the capital. He had beaten off heavy counter-attacks against his northern flank with his Panzer divisions, smashed the Polish 29th Infantry Division, and captured the commander of Poland's reserve. By evening he had bypassed the Lodz Army on his northern flank and virtually enveloped the Krakow Army at Radom on his southern flank. Reichenau was now ordered to destroy the Polish forces at Radom, an operation that would cause delay in the advance on the Vistula, especially since von Rundstedt decided to detach two of Tenth Army's XI and XVI Corps to Eighth Army on Reichenau's left flank.

By 7 September Reinhardt's 4th Panzer Division had finally brought it to the main road to Warsaw. Within hours of this engagement reports reached Rundstedt's headquarters that leading parts of the division were now no less than 20 miles from the suburbs of the capital.

During early evening on 8 September a few miles south-west of Warsaw's Ochota suburb, Polish outposts identified enemy tanks and infantry. Before reports of the sighting had time to be relayed back, Panzers supported by artillery began a number of close-quarter attacks. Though the fire power showed no evidence of a fully equipped motorised division, the bombardment on the suburb was no less impressive. The forces making the first attacks on Warsaw were advanced elements of Reinhardt's 4th Panzer Division. By the time advanced elements of Reinhardt's force arrived at the most southern western edge of the city the inhabitants had already prepared themselves for a prolonged defence. The defence of Warsaw mainly consisted of anti-tank and flak batteries, including anti-tank trenches and barricades, with some buildings left to soldiers to construct fortified positions. The barricades were built with a multitude of crude objects consisting of tram cars, furniture and timber that had been hastily erected across the main roads leading into the centre.

Reinhardt's first assault on Ochota had been immediately repulsed by a heavy unrelenting screen of enemy artillery fire. Dozens of Panzers attempting to storm the suburbs were engulfed in a sheet of flames, severely limiting further tank strikes. Polish resistance in the area had become so stubborn that Reinhardt reluctantly

aborted his attack. Later that evening a dispirited Reinhardt reported to von Rundstedt that, 'After heavy losses, my attack on the city has to be discontinued. Unexpectedly sharp resistance, by the enemy, with all weapons, had reduced a single armoured division, by only four infantry battalions a quite insufficient force to obtain a decisive outcome'. Altogether Reinhardt lost 57 out of 120 Panzers engaged. Apart from illustrating the vulnerability of tanks on their own in urbanised areas, it also showed that the Poles were not prepared to surrender their capital at the first sight of the enemy. It seemed the capture of Warsaw was going to be a long drawn out blood-thirsty battle of attrition.

Although Reinhardt's Panzer division spent the rest of the night counting the cost of its attack, by next morning on 9 September encouraging reports confirmed that the German Army were now beginning to arrive on the west bank of the Vistula. The Poles had not even had time to build a defence barrier along the river, let alone a close-meshed network of field fortifications which had been the intended plan. Before the Vistula the Germans committed their main forces in marginal, wholly unspectacular clearing operations, preparing to the front between the Vistula and Bug. There was never any doubt in the minds of both von Bock and Rundstedt that in the immediate days that followed the vital strategic ground would lie between these two rivers. Here for the Germans glittered the opportunity that would lead them to victory. As for the Poles, they fought on without any rational prospect of success. They were now preoccupied with the struggle to keep on resisting, to build a defensive line along the major rivers and keep hopes alive in the only theatre of the war where Germany felt threatened – the western powers of France and Great Britain. But already, well over 200,000 Polish troops had been captured, killed or injured. With the deteriorating shortages of ammunition and weapons wholesale collapses continued to result in mass surrenders of units, which were swamped by the German spearhead. Many divisions had simply disintegrated, leaving scattered bands of demoralised stragglers roaming the countryside without equipment or leadership.

In the north of the country, however, there were still large parts of the Pomorze and Poznan armies that had been undefeated. The German Fourth Army had simply bypassed them in their furious drive east. Now the Pomorze and Poznan armies took advantage of the situation and hastily joined together into one army commanded by General Kutrzeba. In an attempt to try and crush the onrushing enemy before Warsaw Kutrzeba's army prepared to mount a series of surprise attacks from the Bzura River where they were now situated and strike German forces moving up from the city of Lodz, which had previously fallen.

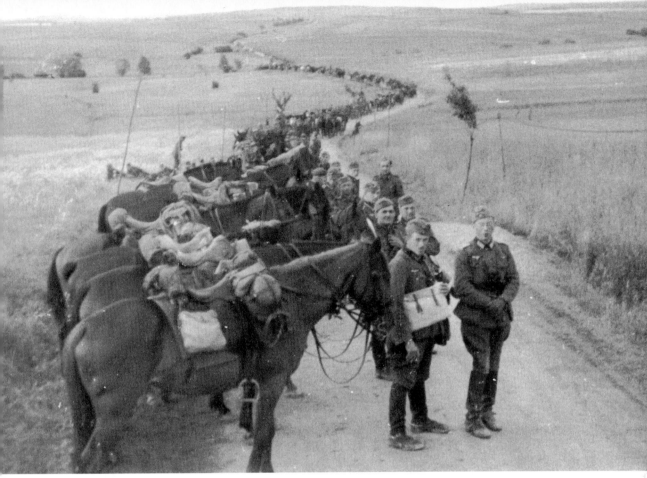

A long column of horses with dismounted men have halted on a road. Because horses played a significant role in the task of conquering Poland, this meant that they were not immune from fatigue and the endless punishing distances they were forced to cover to keep up with the armoured spearheads.

10.5cm guns being pulled by animal draught along a congested road. In Poland rather than using motorised transport, the Germans used horses to pull artillery, ammunition carts, field kitchens, soldiers, bridge-laying equipment and other important material, all of which was needed to sustain the rapid spearheads across Poland.

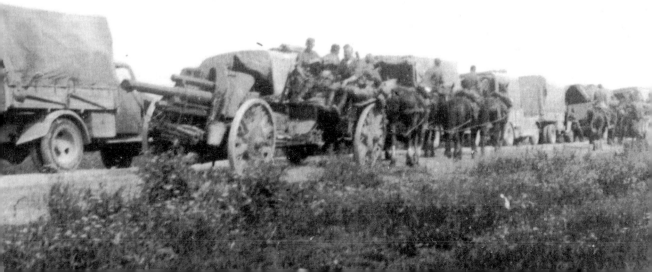

In a field an artillery crew can be seen with their camouflaged 7.5cm le IG 18 gun. Behind them in the distance is a Pz.Kpfw.I. Poland was found by its soldiers to be a land whose sprawling territory contained every type of terrain; hot, dry sandy areas, fertile plains as well as swamps, extensive forests, high mountain ranges and the main rivers that generally flowed north-south of the country and constituted a natural barrier against an east-west assault.

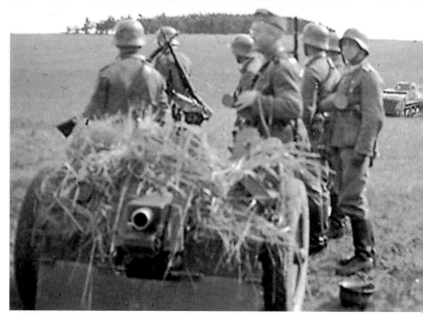

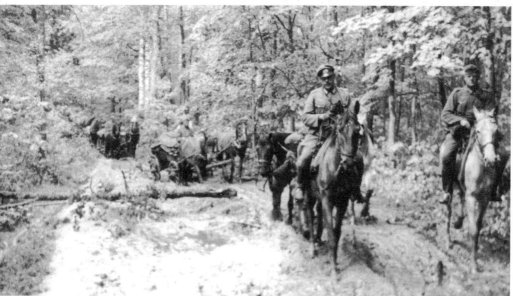

Many of the Polish roads were often sand tracks, and virtually inaccessible to horse-drawn transport. Here horses and their riders and wagons slog along a muddy road after a heavy downpour. Had the invasion of Poland been postponed any later than September, the German Army would have experienced great logistical problems due to the autumn rains.

A column of horses and riders from Army Group North are visible for as far as the eye can see. By 5 September operations in Northern Group began to enter a new and bloodier phase. As Polish columns lay strung over miles of open country trying in vain to escape the impending entrapment, German units began to fight with all their customary ferocity.

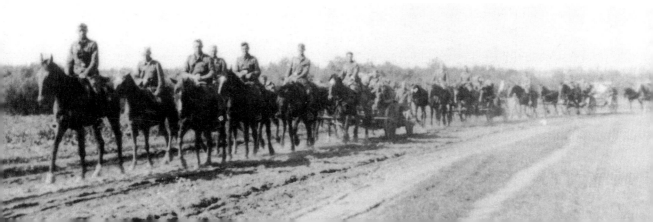

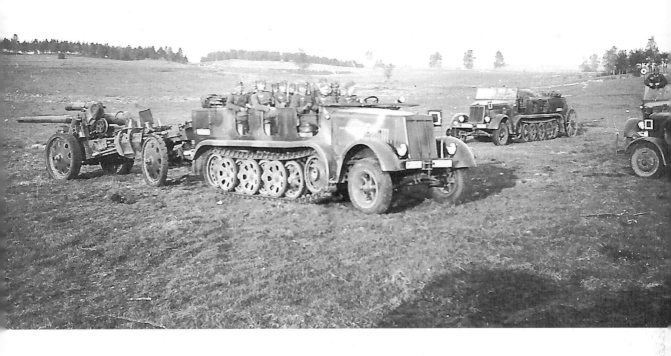

Two photographs of halftracks, one towing a 15cm howitzer and the other a bridging section. The halftrack was used extensively in Poland to tow artillery and supplies to the front along with infantry.

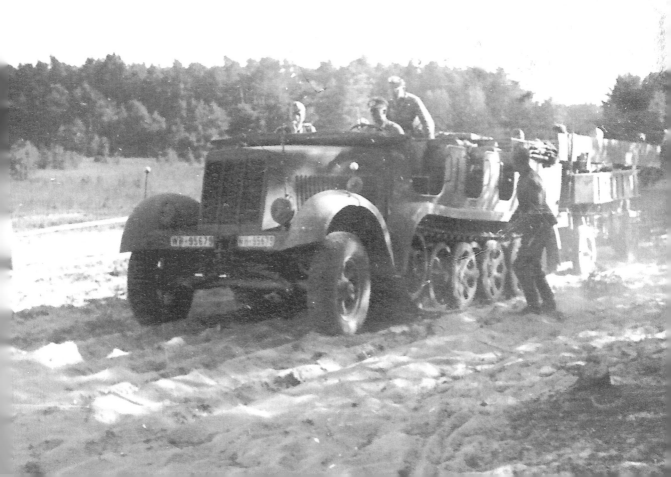

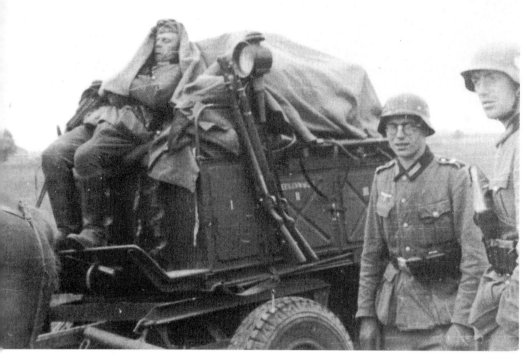

Following in the wake of the armoured spearheads east, infantry became exhausted by the never-ending foot marches that were so common in Poland. Here in this photograph a soldier sleeps onboard a wagon being towed by animal draught and uses part of the tarpaulin as a cover.

A posed shot showing two machine gunners with their crew onboard a train destined for the front lines in Poland. During the war one of the quickest and most efficient ways of transporting troops to the front was by railway.

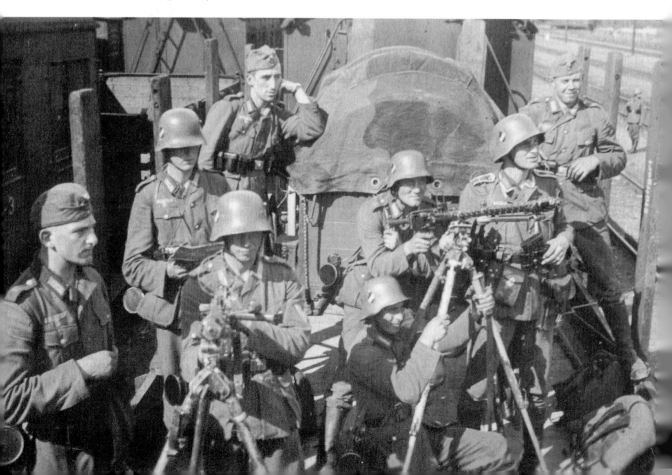

Two photographs one showing members of an artillery crew inside a halted halftrack and another showing a crew during a respite on the side of a hill. The halftrack had sufficient seating for the entire gun crew. However, when moved by horse, the howitzer always had to be divided into two parts with separate wagons for the barrel and gun carriage.

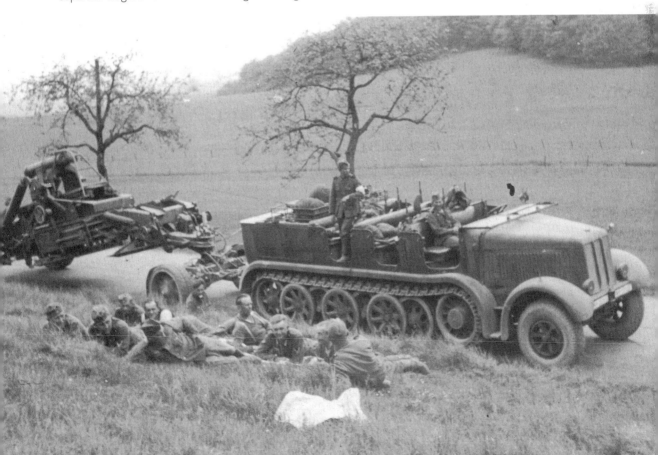

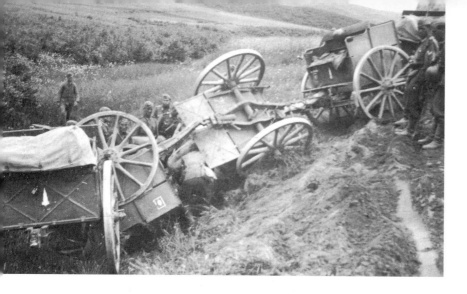

Horse drawn limbers carrying supplies have come off a road. The German drive east was constantly hampered by the bad road system. Often tracked vehicles avoided the roads and went across through fields.

A badly damaged Pz.Kpfw.I. The vehicle has been hit by an enemy anti-tank shell that has penetrated the side of the turret. By 1939 the tank was effectively obsolete, but still used extensively in the field against the Poles.

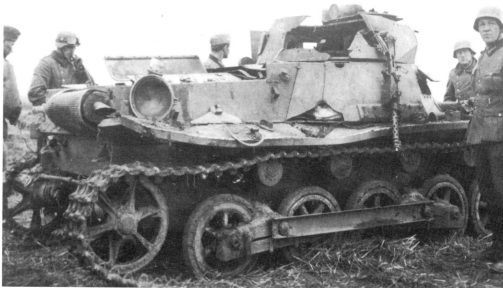

A typical scene in Poland showing a long column of horse drawn limbers full of supplies halted on a road. From the air this stationary convoy would have been as easy target. However, by 5 September the Polish Air Force was almost non-existent. The majority had been either destroyed or was hiding at various airfields further east.

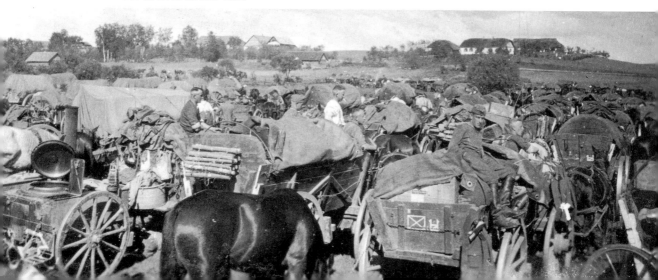

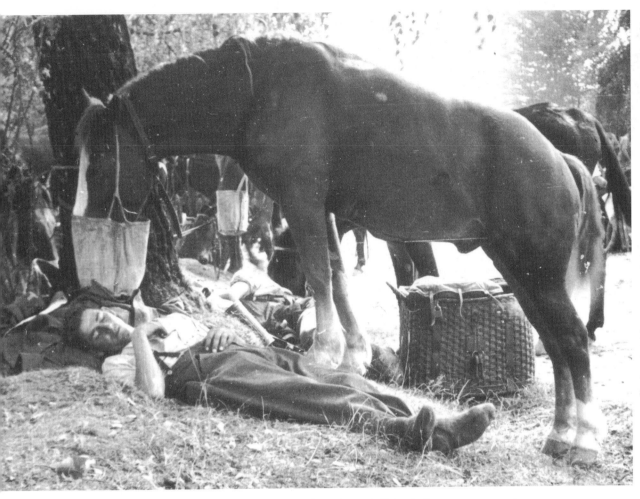

Men and their horses rest during the relentless drive through Poland. German commanders were praised by their superiors for keeping their attacking infantry moving, not to cause incessant delays whenever they were confronted with the least sign of opposition. After nearly a week of constantly being on the move, the men and their horses, which they relied on so heavily, were completely exhausted.

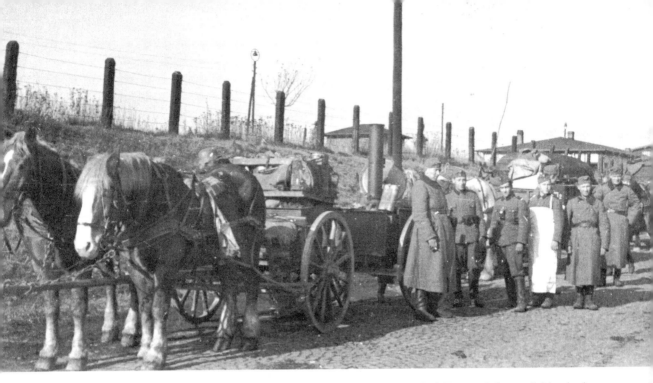

Two photographs showing infantry with their horses. In Poland a typical German infantry division had approximately 5,300 horses, 1,100 horse-drawn vehicles, 430 motorcycles and 950 motor vehicles. A typical rifle company transported consisted of three-horse wagons, on which the troops loaded all their packs and other supplies.

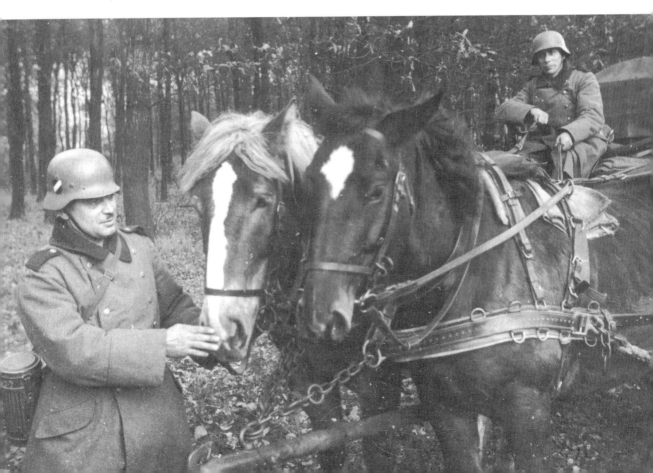

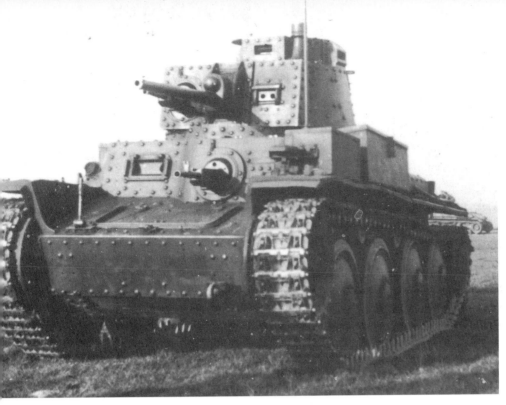

A stationary Pz.Kpfw.38 (t) in a field. These tanks were reliable and easy to maintain and were used in the Panzerwaffe in Poland to bolster the already large contingent of light tanks that were spearheading across the country.

Two stationary Pz.Kpfw.35 (t) are parked along a cobbled road inside a captured Polish town. The fruits of the great dash east were exhilarating for the men riding the tanks and trucks. It had been an unopposed thrust across country against a disorganised jumble of retreating Polish units.

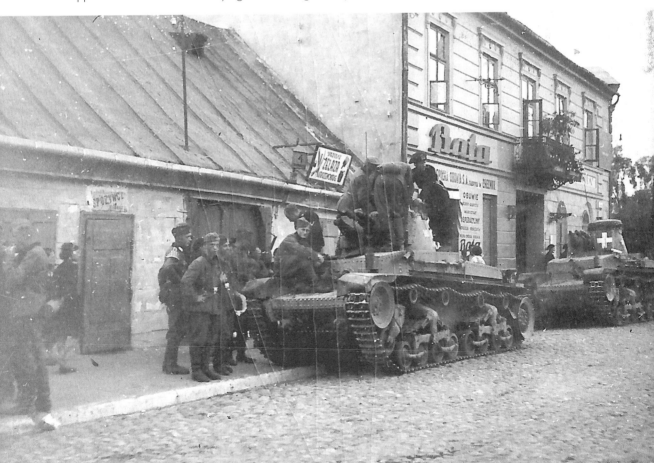

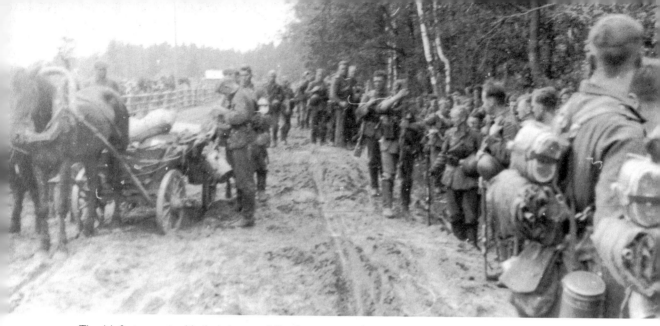

Tired infantry rest with their horses following more or less a continuous unopposed march across Poland for almost a week. The horse too, which played a significant part in conquering Poland, were not immune from fatigue and the endless, punishing distances which they were forced to cover in order to keep up with the Panzers. Their load was often huge as well putting great strain on their heart.

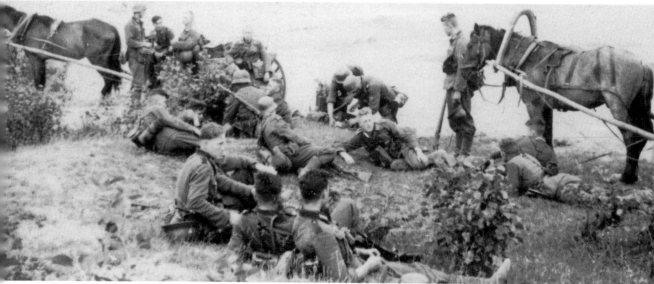

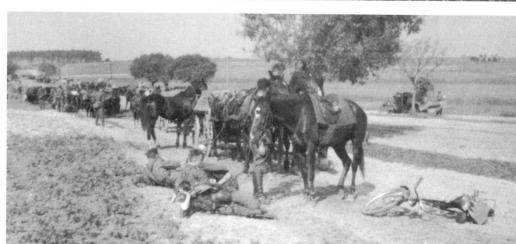

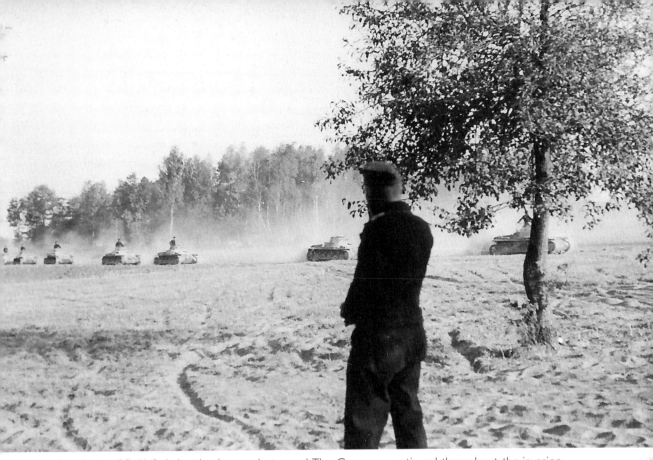

A column of Pz.Kpfw.Is hurtle along a dusty road. The Germans continued throughout the invasion to crush enemy defences, disrupting the logistic network and not being slow to use terror as an additional weapon. For the Poles, however, it was the beginning of the end. They were slowly withdrawing into a long, narrow pocket, within which they were to eventually be encircled, isolated and then destroyed.

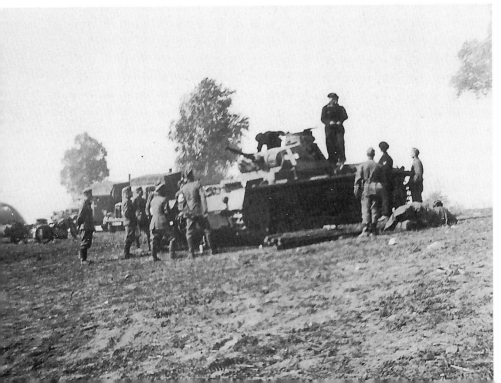

The crew of a Pz.Kpfw.III confer with soldiers during a break in the advance. Because the Polish Air Force had virtually been wiped out practically all Panzer crews did not need to take precautionary measures of camouflaging their machines against possible air strikes. Note how visible the white cross is on the side of the turret.

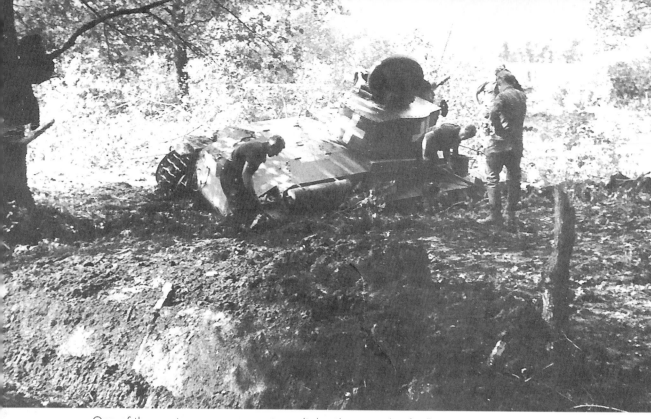

One of the most common occurrences during the campaign for Panzer crews was trying to avoid the congested roads. Here a Panzer has turned off the road across country, but has unfortunately sunk into the soft soil.

German infantry watch as a Pz.Kpfw.III passes by. Note the white cross erased on the side of the turret. This vehicle is travelling across country avoiding the appalling traffic jams that were constantly clogging the advance by refugees, and by the Polish army vehicles entangled upon the roads that had been strafed by air attack.

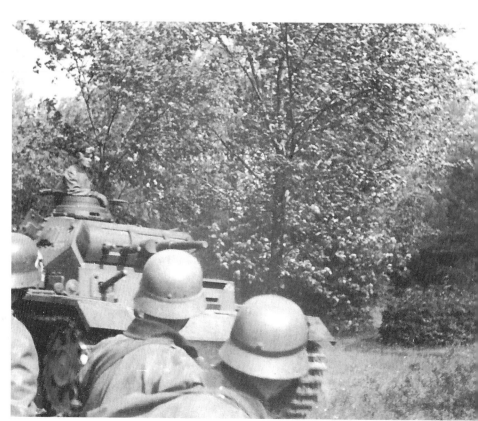

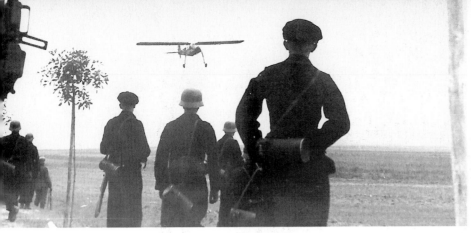

Armoured crews wearing their familiar black Panzer uniforms and berets watch a reconnaissance aircraft on its final approach into a field. The Germans used extensive ground and aerial reconnaissance patrols to survey enemy positions.

Horse drawn transport move steadily along a road. Note that the middle part of the road has been divided by logs for either returning traffic from the front or for faster moving vehicles.

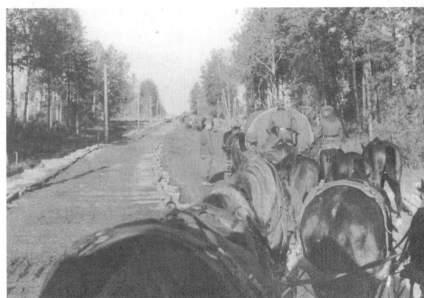

German infantry and Panzer men stand in front of a Pz.Kpfw.I with captured Polish prisoners. Although in many areas of the disintegrating front the Poles were ordered to hold their positions, they soon found that German units were surrounding them in their hundreds and often capturing them without a fight.

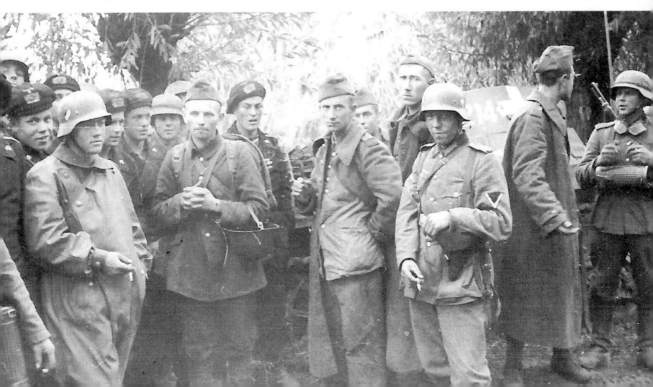

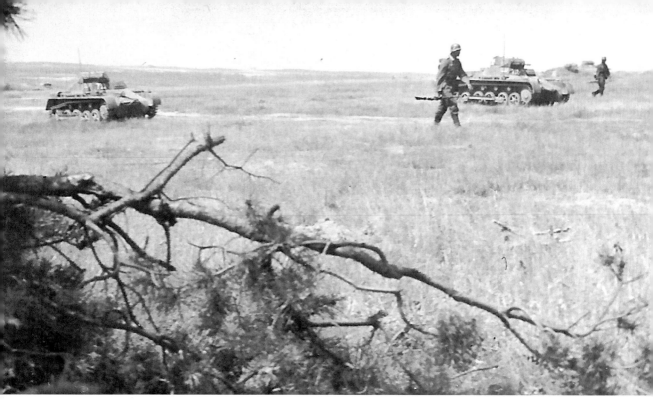

Pz.Kpfw.Is and infantry move forward across a field. Advancing down every road, across many adjoining open fields was the huge might of the German Army. There were the convoys of tanks, guns, heavy artillery being pulled by hundreds of horses and halftracks, armoured cars, ammunition and supplies for the troops, and bridging sections. Divisional headquarters were also on the move, with their staff cars, command caravans and radio vehicles. And wave after wave, chocking every road, were the troops marching – in trucks or on the back of armoured vehicles.

A damaged Pz.Kpfw.35 (t) knocked out of action by anti-tank fire is being transported on a trailer bound for one of the workshops in the rear.

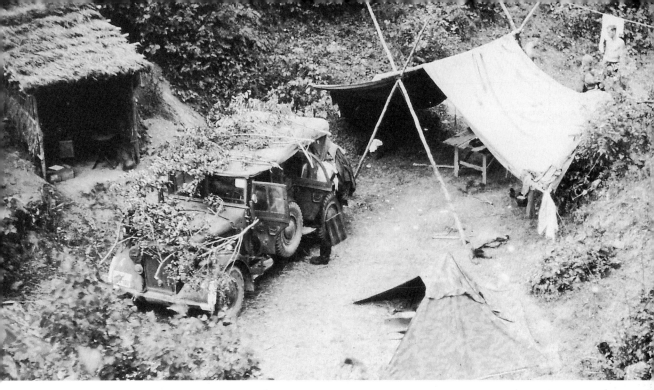

A forward observation command post. Here reconnaissance vehicles would leave the post in a variety of armoured cars and motorcycles in order to probe and survey the battlefield. Often they would encounter enemy fire and then return with vital information, specifically regarding the location of the enemy.

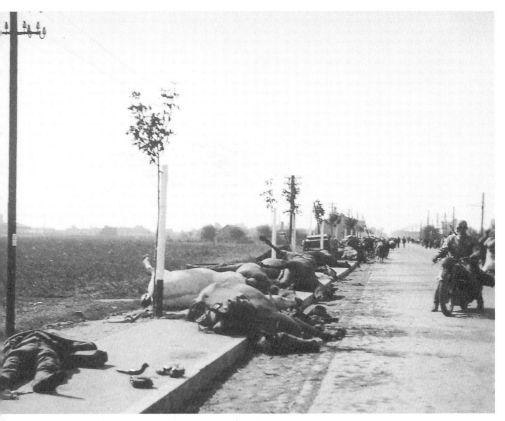

A German motorcyclist halts on a road outside a captured town and surveys the carnage of battle. Littered along the pavement are dead horses and soldiers mingled with damaged wagons and limbers. Already well over two hundred thousand Polish troops had been captured, injured or killed. Wholesale collapses in morale continued to result in mass surrenders of units swamped by the German spearhead.

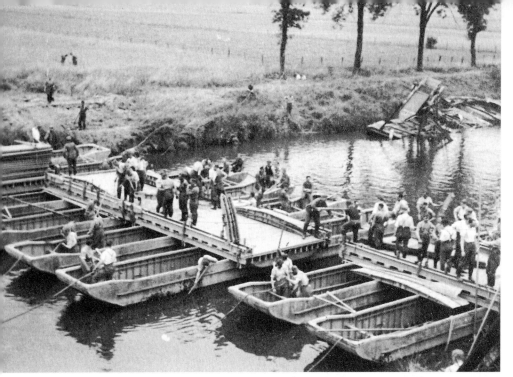

A pontoon bridge is being erected over the Narew River. On the Narew Division Kempf clashed at Rozan on 6 September and fought a bitter action there seizing the bridgehead, much to the anger of the Poles who were bitterly defending it.

Two German soldiers in an observation post use a pair of scissor binoculars to survey enemy movements. These binoculars were nicknamed 'donkey's ears'.

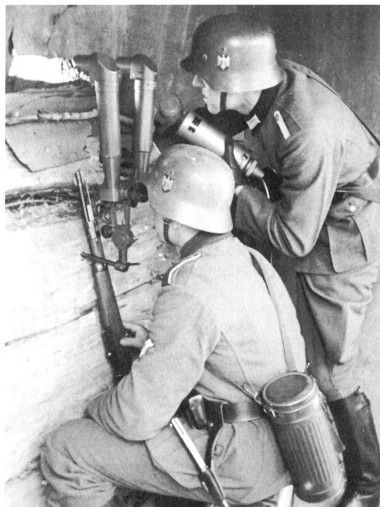

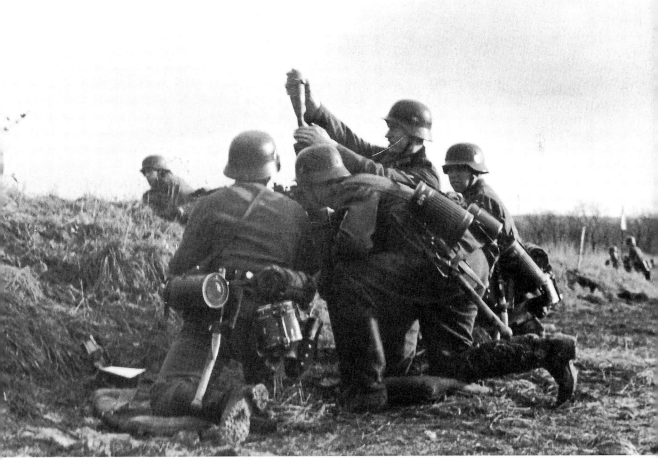

A mortar crew in action attacking the rear of their defensive positions on the Lower Narew. Throughout the 6 September the Poles continued trying to defend the river but German firepower continued to be overwhelming.

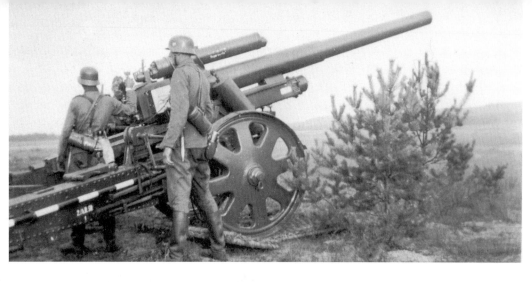

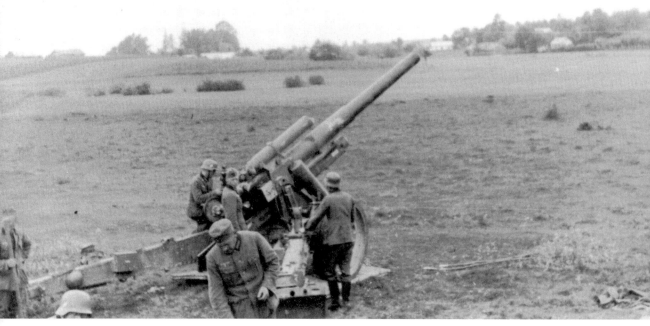

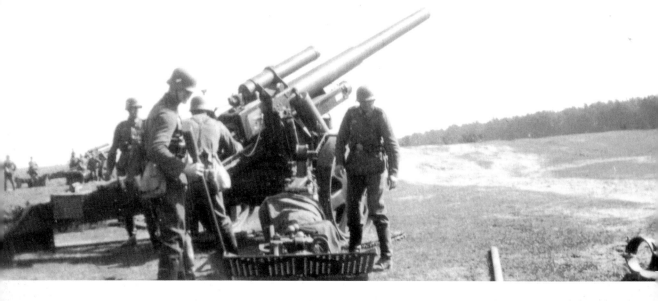

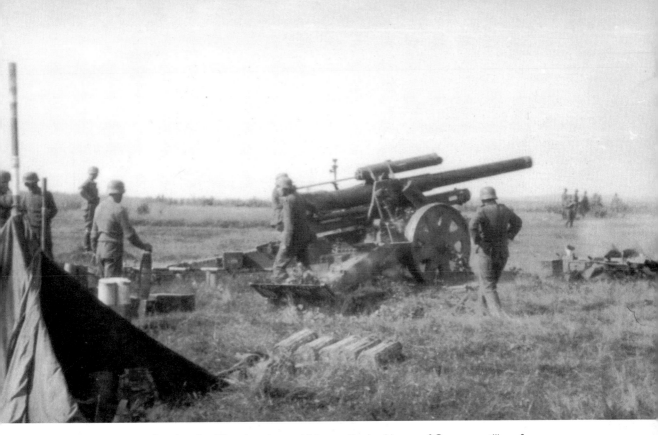

Five photographs showing the 15cm howitzer, which was the backbone of German artillery firepower in Poland. When an attack progressed, heavy fire was maintained to engage successive lines of anti-tank defences. When the tank managed to break through the enemy forward defence lines, all the heaviest fire fell well ahead of the armoured assault or outside their sector. Every artillery commander was aware that the flanks of a tank's attack were also vulnerable, so they assigned the artillery units the task of protecting the flanks by barrage of high explosive and smoke shells.

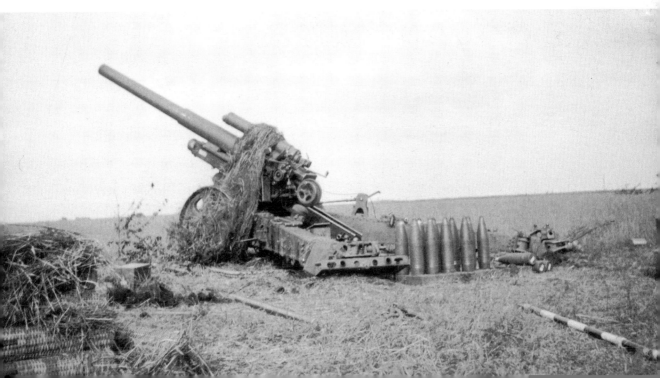

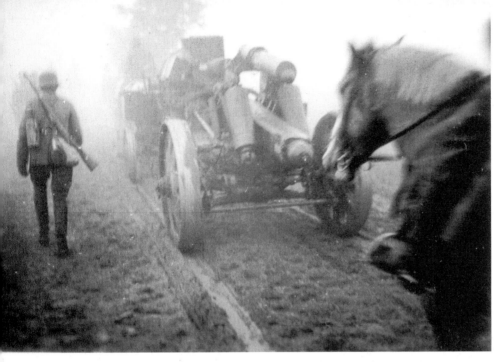

A 15cm howitzer is being towed along a dusty road by animal draught. Though the horse was much slower than tracked vehicles, it was the only alternative from tracked vehicles to move heavy artillery and supplies from one part of the front to another. In Poland, the advanced spearheads moved so quickly that heavy artillery was seldom used to soften up positions to allow the tanks to pour through.

A much preferred way to transport artillery to the forward edge of the battlefield. Here a halftrack is towing a 15cm howitzer along a road destined for the front lines.

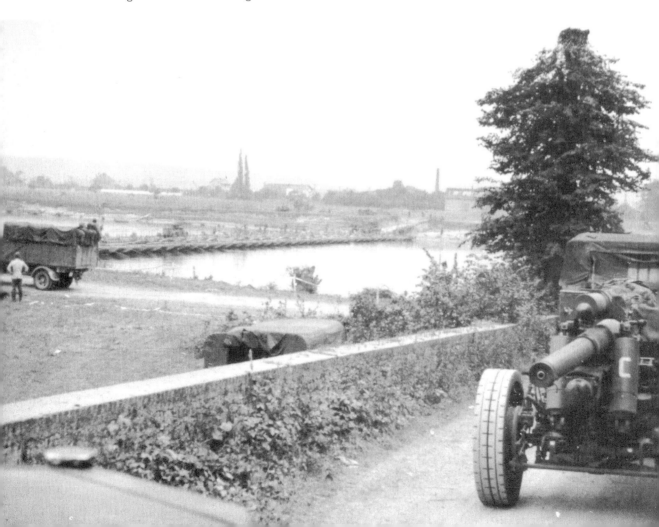

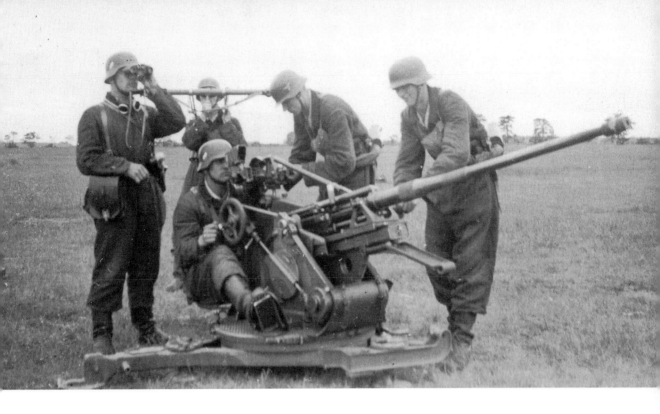

Two photographs showing a Luftwaffe flak crew with their 2cm flak gun. The 2cm flak gun was most commonly used as a light anti-aircraft gun during the Polish campaign and all the crews were relatively successful downing what was left of the Polish Air Force.

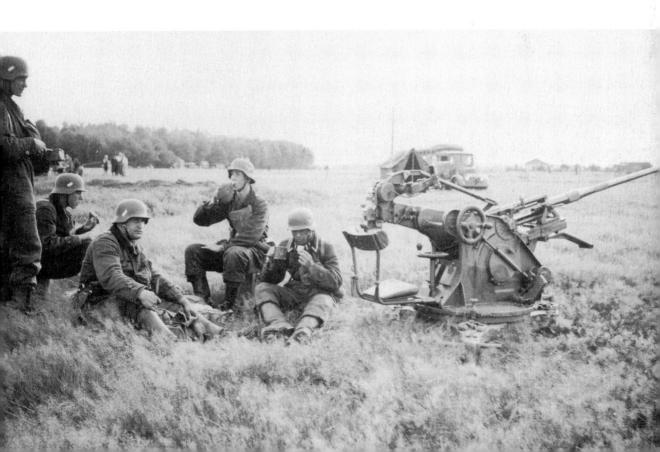

A PaK35/36 crew aiming their gun along a road. The PaK35/36 became the standard anti-tank gun of the German Army during the early part of the war. It weighed only 432kg (952.5lb) and had a sloping splinter shield. The gun fired a solid shot round at a muzzle velocity of 762m/s (2500ft/s) to a maximum range of 4025m (13200ft).

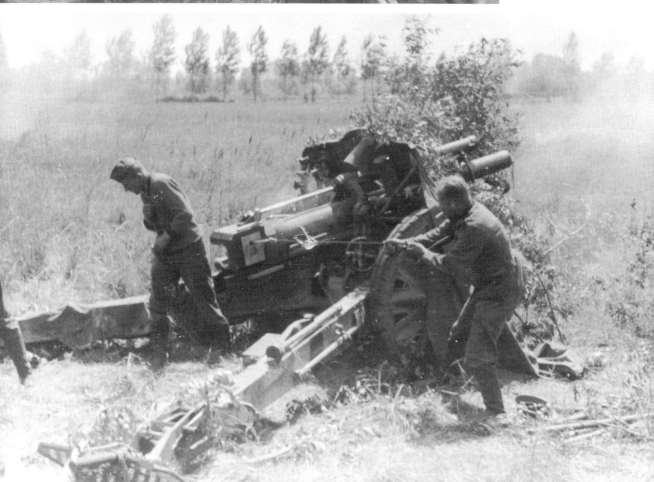

A nice photograph showing the moment a 10.5cm infantry gun is fired in action against a Polish position. This 15cm gun was used as the standard German infantry heavy cannon and supported the German Army into battle.

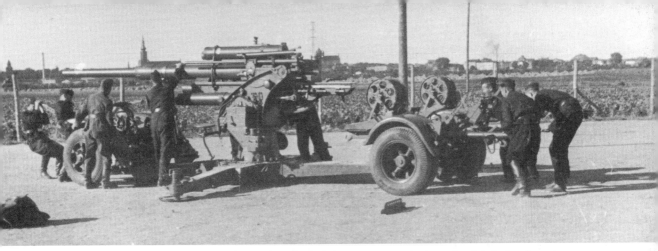

Here an 8.8cm flak crew prepares to manhandle their heavy weapon back on the flak limber in order to transport it to another part of the front. The 8.8cm flak gun became the most famous German artillery gun of World War Two. It was specifically designed for a dual purpose role, possessing a very potent anti-tank capability as well. In Poland troops did not appreciate the full of effectiveness of the weapon until later on in Russia.

Troops in position with their PaK35/36 anti-tank gun. Though these guns were very effective against Polish armour, it would not be until the war against France the following year that the German Army became aware of the tactical limitations of the gun as their forces increasingly encountered heavier enemy armour.

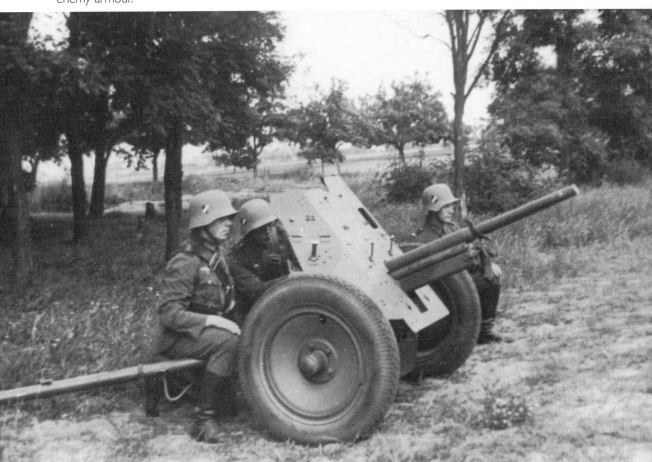

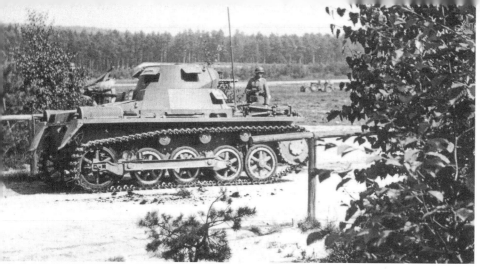

Four interesting photographs
showing the Pz.Kpfw.I
operating in Poland.

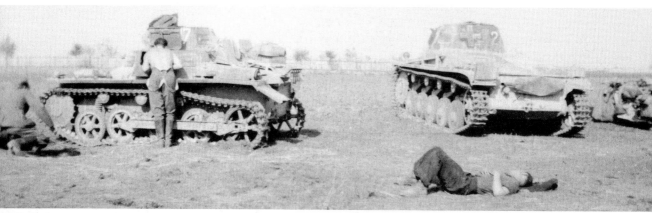

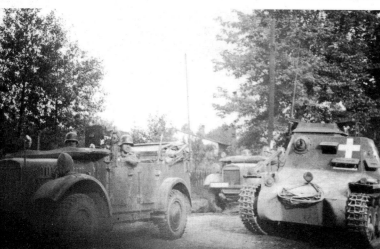

This light tank was armed with a 7.92mm gun
and also carried two radios, the Fu2 and Fu6. The
Ausf.A type variant was powered by a Krupp
M305 engine that generated 57hp. The Ausf.B
variant was slightly heavier and was fitted with a
Maybach NL38TR 6-cylinder 100hp engine. The
Pz.Kpfw.I formed a major part of the strength of
the Panzerwaffe in Poland. Although it would be
soon overshadowed by much more powerful
tanks like the Pz.Kpfw.III and IV, its contribution to
the German Army`s early victories during the
Second World War were undoubtedly very
significant. Within three years of the war the
Pz.Kpfw.I was finally taken out of service and
given to the police and anti-partisan units.

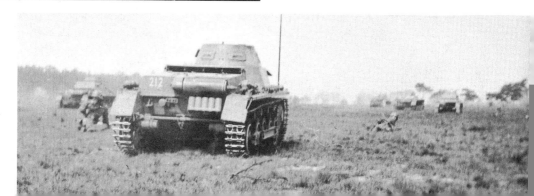

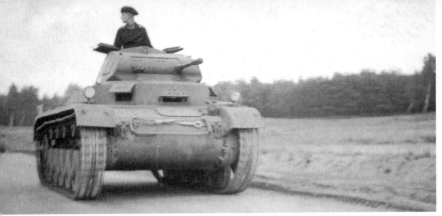

A Pz.Kpfw.II advances along a road. A total of 1226 Pz.Kpfw.IIs were employed for the Polish campaign and despite the vehicle suffering from very thin armour, which offered minimal protection in battle, it was used successfully against the Polish Army, which only possessed antiquated armour.

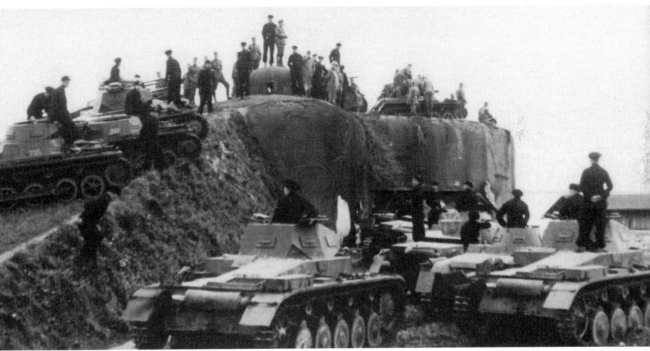

Two photographs showing German infantry and Panzer men posing for the camera after successfully capturing a Polish bunker. Pz.Kpfw.I and IIs can be seen halted in front of the fortification.

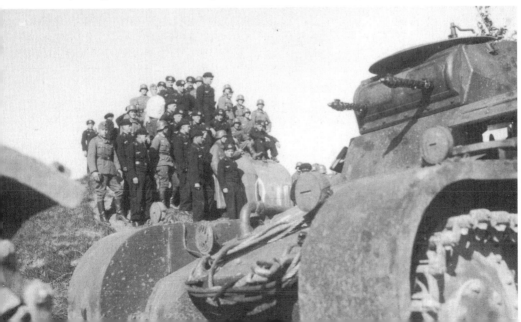

The Polish Army modernised many of their bunkers from World War One in to strong fortresses consisting of anti-tank and anti-aircraft equipment.

Three German motorcyclists rest at the side of the road with their machines. Motorcyclists were used extensively in Poland and were also utilised for reconnaissance duties as well. Because they were very versatile machines it enabled the rider to survey enemy positions until he encountered fire and then returned swiftly with important data and other important information relating to location and strength of the enemy.

A motorcycle combination can be seen advancing along a road towards a bridge. Each Panzer division in Poland had a very capable motorcycle company. In fact, a whole battalion of Panzer division`s rifle brigade were given motorcycles with sidecar combinations.

An interesting photograph showing a motorcycle combination navigating along a muddy road after a heavy downpour. Note the soldier seated in the sidecar armed with a mounted MG34 machine gun for local defence.

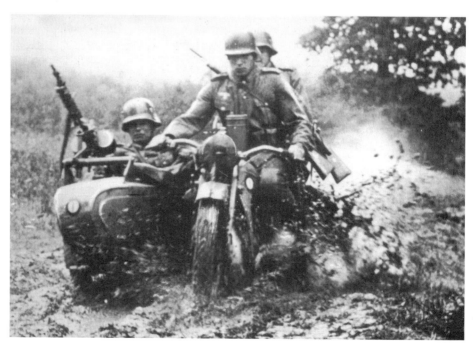

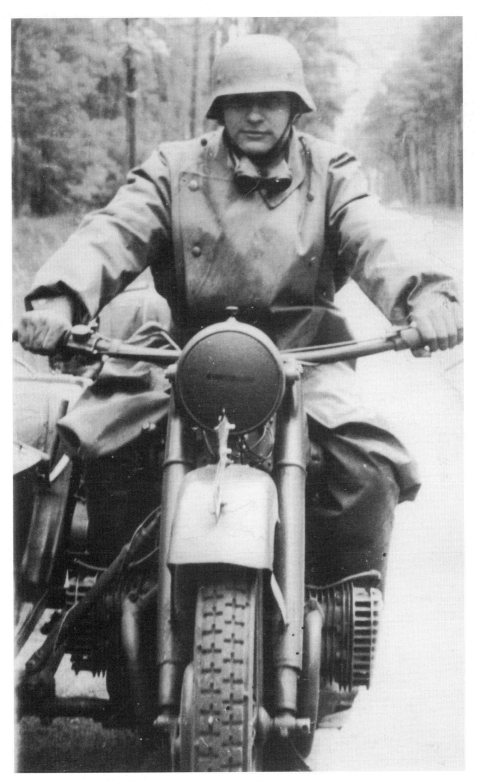

A posed shot showing a motorcyclist wearing a double-breasted rubberised motorcycle coat. The garment was waterproof and was worn with army canvas leather issue gloves or cloth mittens, with overshoe leggings or army boots.

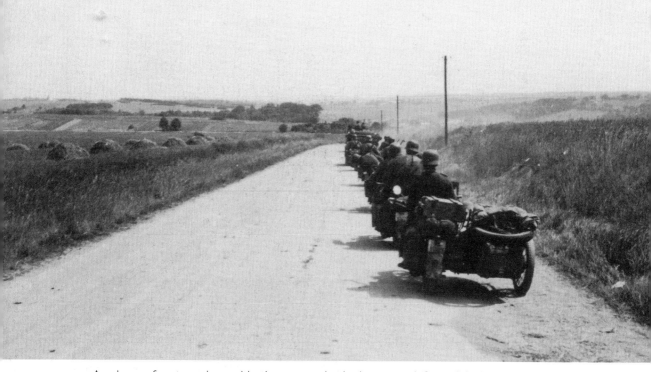

A column of motorcycle combinations move slowly along a road. One of the hazards of travelling by motorcycle, especially in Poland, was the lack of good-quality roads for vehicles. Motorcyclists that decided to avoid the roads and travel across country often proved a perilous undertaking, and the casualty rate among motorcyclists was inevitably high.

A motorcycle combination advances along a road with a long column of support vehicles closely following behind. Preparing for action relied on various light and heavy trucks and many civilian and armoured vehicles for transport. Maintaining the momentum the armoured drive through Poland was vital to success, and without support vehicles, the whole advance might stall.

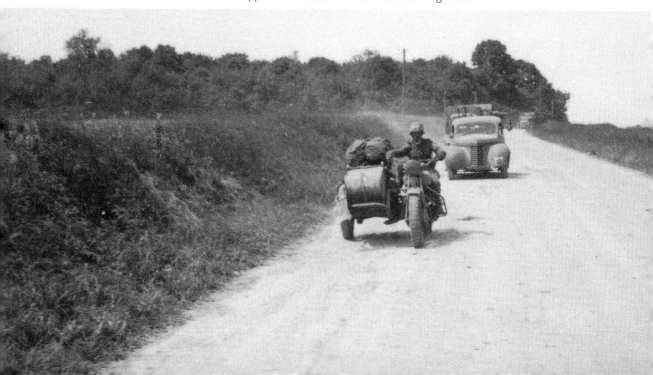

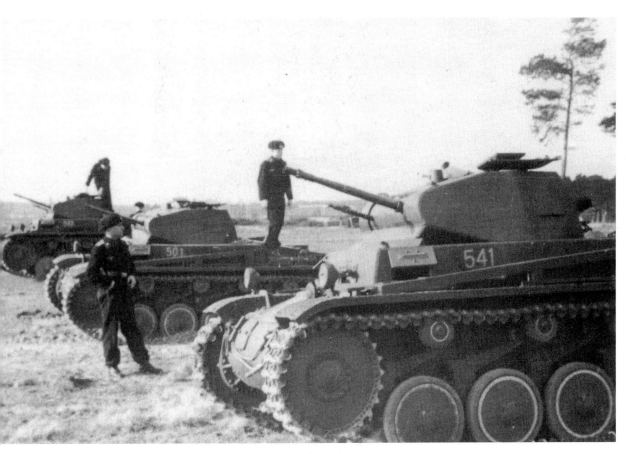

Three Pz.Kpfw.IIs have halted in a field. This tank played a very crucial part in the invasion of Poland and its standard 2cm cannon, which could fire 280 rounds per minute, proved more than capable of knocking out Polish armour.

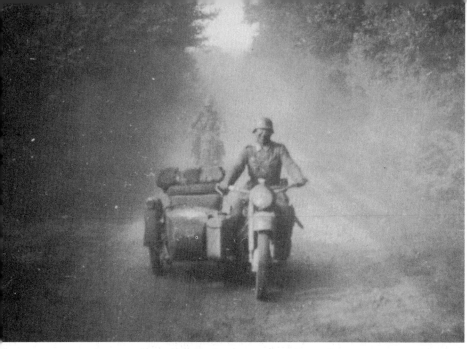

Two photographs, one showing a motorcycle and a motorcycle combination driving along a dusty road, and the other a posed shot of a ride on a motorcycle. Although a great number of motorcyclists in Poland rode into battle and dismounted to fight, motorcycles and motorcyclists were regarded as vulnerable to small arms fire and booby traps.

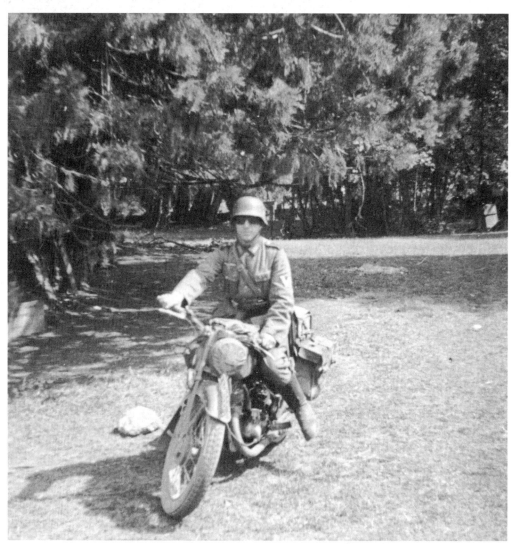

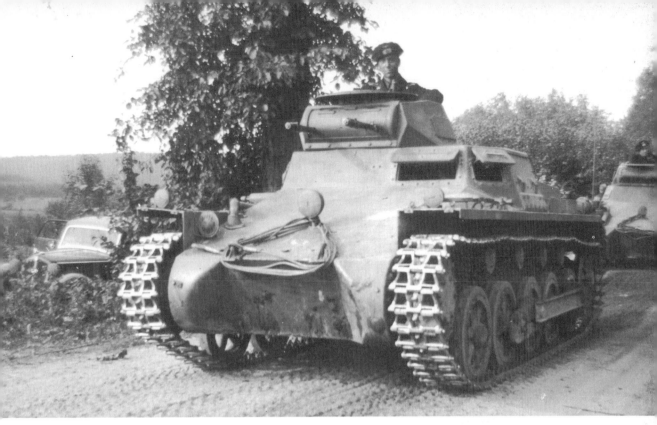

Two photographs showing a Pz.Kpfw.I. Contrary to popular belief during the first week of the invasion a number of German tank attacks were poorly coordinated with the accompanying infantry. This was a reflection of the difficulty German commanders had of putting the new doctrine of Blitzkrieg into practice.

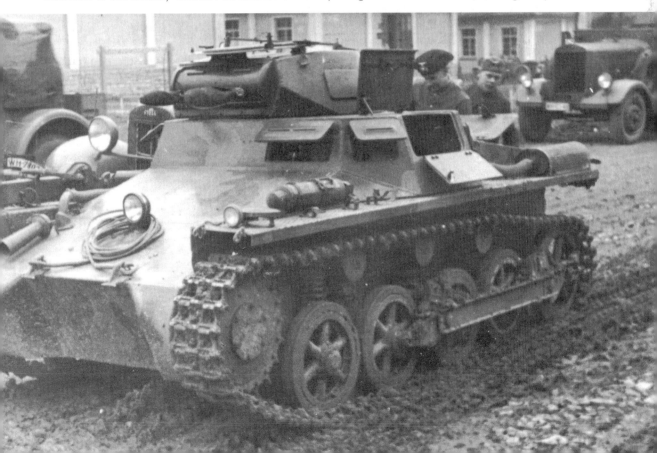

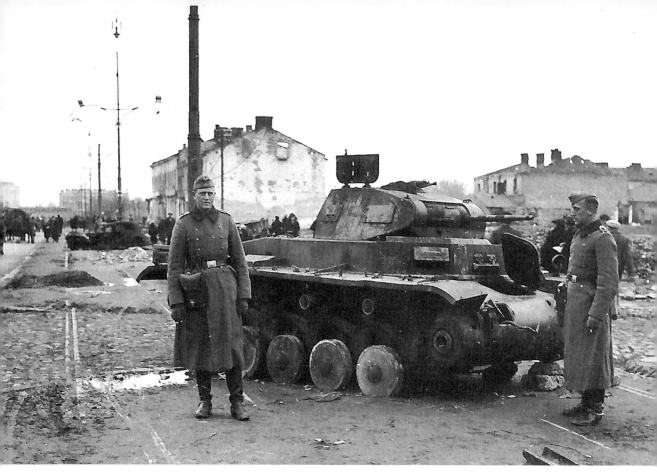

After a week of campaigning the Poles were withdrawing back towards Warsaw. By 7 September Reinhardt`s 4th Panzer Division had finally brought it to the main road to Warsaw. During early evening on 8 September a few miles south-west of Warsaw's Ochota suburb, Polish outposts identified enemy tanks and infantry. To Reinhardt`s surprise the first assault on Ochota was immediately repulsed by a heavy unrelenting screen of enemy artillery fire. Dozens of Panzers attempting to storm the suburbs were engulfed in a sheet of flames, severely limiting further tank strikes. Here in these two photographs stands a knocked out Pz.Kpfw.IIs in Warsaw's suburb.

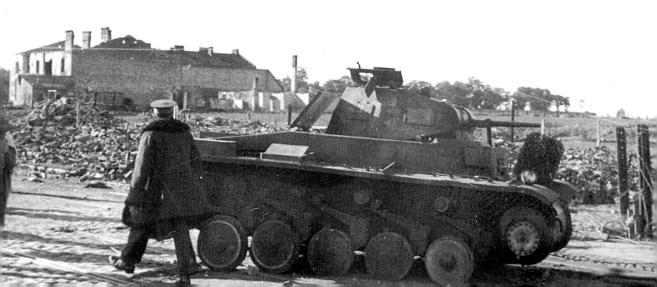

Chapter Three

Battle of Bzura

On 9 September as four German infantry divisions from Eighth Army pushed along the Bzura attacking towards Lowicz, strong Polish formations from what was now called General Kutrzeba's Army moved across from the Poznan province and advance south on the weak German northern flank. General Ulex's X Corps, which had been following the greater part of Eighth Army's thrust on Warsaw and the Vistula, were reported to be advancing steadily along the Bzura. At first light and unknown to X Corps or even to reconnaissance patrols, Kutrzeba saw his chance and made a surprise attack southwards against General Briesen's 30th Infantry Division, and parts of the 4th and 16th Infantry Divisions. In a desperate attempt to keep casualties to a minimum, the 30th Infantry Division crossed the river to the southern bank where it intended to prepare a counter-attack. Throughout the day German troops frantically began digging in to beat off the enemy, but found it difficult to stave off the Polish attack. German troops were already beginning to flee across open fields heavily infested with well armed enemy troops. By late afternoon it was reported that most of the German divisional NCOs and officers were already dead or wounded. During the thick of battle, Ulex anxiously telephoned General Blaskowitz field-headquarters appealing for help. Immediately Blaskowitz ordered Eighth Army to halt its rapid advance on the Vistula and Warsaw, swing-round and repair the damage to its rear caused by Kutrzeba's force. Von Rundstedt decided to withdraw elements of Tenth Army from the besieged capital and move it to the Bzura to strengthen the ravaged Eighth. As Reichenau's infantry divisions swung west, in Warsaw resistance intensified. It seemed as though the Poles defending the city had heard by word of mouth the successful gains on the Bzura. In a fierce effort to annihilate the capital's defenders Reinhardt's Panzers resumed a number of heavy close-quarter attacks, but by early evening it once again failed to crush the strong Polish defences. Even the use of heavy close coordinated air-strikes did nothing to weaken the city's ability to hold-out. To make matters worse by early evening Reinhardt received a reconnaissance report that large enemy formations were advancing along the east-west road between the town of Sochaczew and Warsaw. But what the message did not explain, and in fact what was not known at the time, was that the enemy force was made up from large parts of the Poznan and Pomorze armies under the command

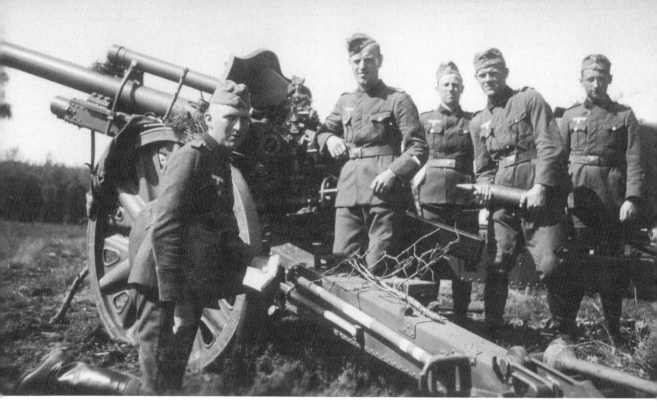

Two photographs taken in sequence showing an artillery crew posing for the camera with their 10.5cm howitzer. It was primarily the artillery regiments that were given the task of destroying enemy positions and fortified defences and of conducting counter-battery fire prior to an armoured assault.

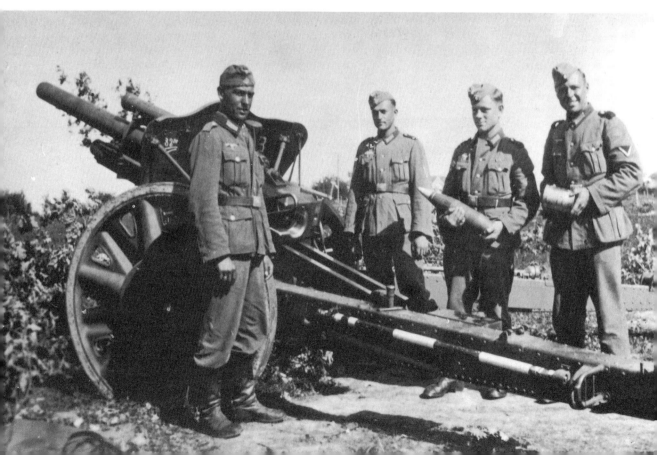

of General Kutrzeba. The only obstacle between this strong Polish force and Warsaw was Reinhardt's division. The bulk of Reinhardt's units were already deployed east-west of the capital. Neither the 4th or Schmidt's powerful 1st Panzer Division were in physical contact with the other to meet the developing threat. To protect the armoured force from complete destruction Reinhardt immediately ordered his division to face back-to-back, east and west, and then proceed to contact General Hoepner's command post, asking for urgent assistance. Hoepner wasted no time and called up Hitler's foremost fighting machine the SS-Leibstandarte Panzer regiments, which were immediately launched into an infantry attack in the west sector of the suburb. At the same time Reinhardt directed his 5th Panzer Brigade northwards to cut the Modlin to Warsaw road, where it was believed that Polish units were punching a hole through an unguarded sector north of the city. The remaining units of his group facing the capital were ordered to stem further Polish attacks out of Warsaw, while the remainder of the units facing west were ordered to dig-in and hold its positions.

Approaching in the swirling dust from the west, determined to reach the capital at all costs, came infantry divisions from General Kutrzeba's Army. To meet this developing threat, the 103rd SS-Leibstandarte artillery regiment was quickly employed along the Warsaw to Sochaczew road. What followed was a bloodthirsty contact that was fought doggedly and methodically in and around the battered town of Sochaczew.

The sheer scale of the battle of the Bzura was now beginning to unfold. By 10 September it was estimated that nearly thirty German and Polish divisions, including some 400,000 men were being drawn to the area. The High Command of the Army, OKH (Oberkommando des Heeres) estimated there to be at least a quarter of the Polish Army already embroiled in the region. But the cost to the Poles was high. Along the Bzura near Sochaczew the conflict had revealed the horror and devastation. Columns of dead civilians, troops, cattle and horses which had perished during intensive and prolonged attacks by the army and units of the SS-Leibstandarte, laid tangled inside ditches and clearings along the road leading to Warsaw. Refugees, which had been withdrawing under the protection of the Polish Army, were caught in the hurricane of fire and gunned down. The majority of dismembered human remains and their belongings were gathered in piles on both sides of the road. But still the Poles continued to fight on.

Elsewhere, Army Group South had achieved notable success. In the region around the city of Radom, where intensive fighting had been raging for a number of days, General Schwedler's IV Corps, General Wietersheim's XIV Corps, and General Hoth's XV Corps, had been fighting against elements of the Lodz Army, now called General Rommel Group (not to be confused with the German General, Erwin

Rommel), another newly created army, the Lublin Army, and parts of the Krakow Army, had encircled these badly depleted Polish forces, which yielded some 60,000 prisoners.

Further east advanced German units from the Tenth Army successfully reached the Vistula, whilst simultaneously List's army were arriving on the bank of the San River. In the north both the Fourth and Third armies made a series of combined attacks across the Narew, reaching parts of the Bug River, which were heavily fortified. As for the Polish Army it had been vanquished. Most of its 35 divisions had either been destroyed or caught in a vast pincer movement that closed around Warsaw. The German objective was now to crush what was left of the dazed and disorganised Polish units, and destroy them, completing a second much deeper envelopment aimed at the Bug, 100-miles east of Warsaw. The plan was for Army Group North to spearhead further east and for the Fourth Army to occupy the city of Brzesc, which was situated on the Bug. Fourteenth Army was to continue its drive north between the San and Bug and link up with Army Group North.

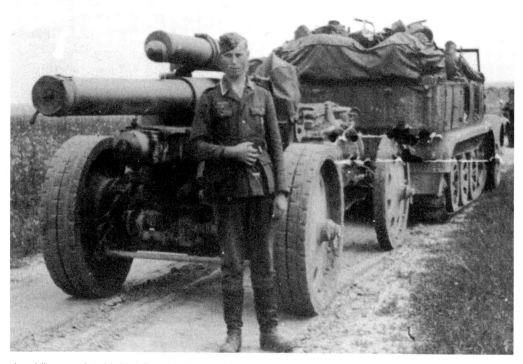

A soldier stands with his 15cm howitzer, which is being towed by a halftrack. Employment of artillery was a necessity to any ground force engaging an enemy. Both infantry and motorised artillery regiments became the backbone of the fighting in Poland, despite how short the campaign was.

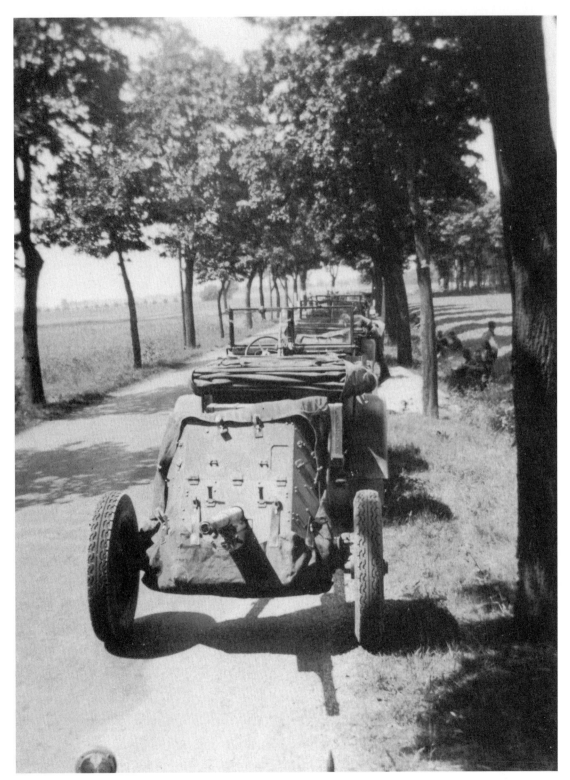

A column of vehicles have halted on a road. Unusually a light Horch Cross-Country vehicle has a PaK35/36 on tow. During the invasion of Poland, and indeed throughout the rest of the war, the Germans improvised a number of various military and civilian vehicles to tow and carry vital weapons and ammunition to the front lines.

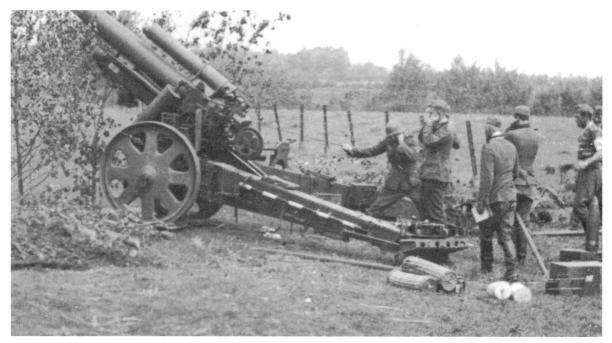

A photograph taken capturing the moment a 15cm howitzer is fired. By 9 September wholesale collapses in morale continued to result in mass surrenders of Polish units swamped by the German spearheads. Divisions had simply disintegrated, leaving scattered bands of demoralised stragglers roaming the countryside without proper equipment or leadership.

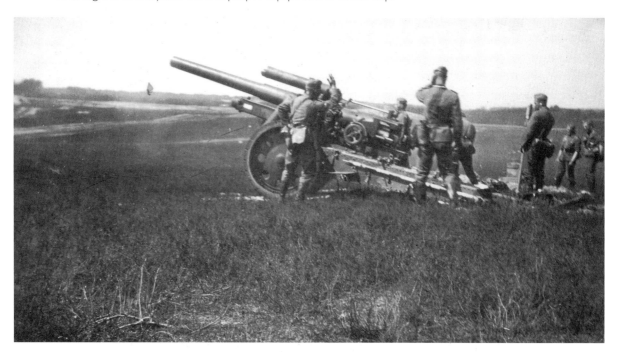

Another photograph showing a 15cm gun in action. This photograph was taken during the Eighth Army`s heavy fighting along the Bzura River. On 9 September as four German infantry divisions from Eighth Army pushed along the Bzura attacking towards Lowicz, strong Polish formations from what was now called General Kutrzeba's Army moved across from the Poznan province and advanced south on the weak German northern flank. What followed was a bitter battle.

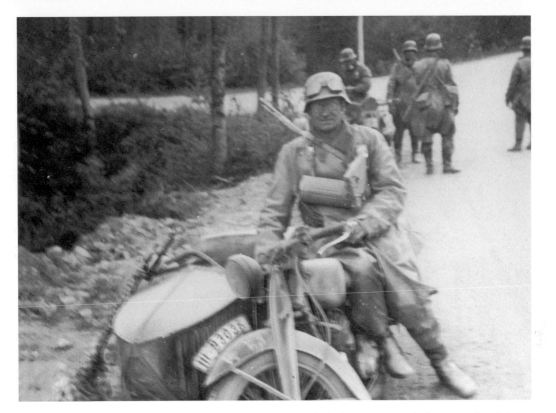

Motorcyclists with their motorcycle combinations have halted on a road during intensive fighting against enemy forces from General Kutrzeba's Army. Throughout 9 September the German Eighth Army remained in close cooperation with Tenth Army's advance. Leading elements made probing attacks east of Lodz against a number of newly organised Polish groups which had been forced together out of destroyed or broken divisions.

A Pz.Kpfw.I advancing across a field. Such was the rapid advance of the German Army that many units were now beginning to arrive on the west bank of the Vistula by 9 September. The Poles had not even had time to build a defence barrier there, let alone a close-meshed network of field fortifications which had been the intended plan.

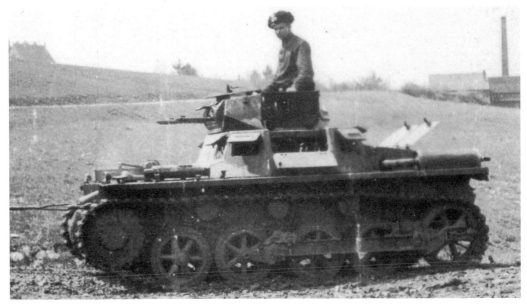

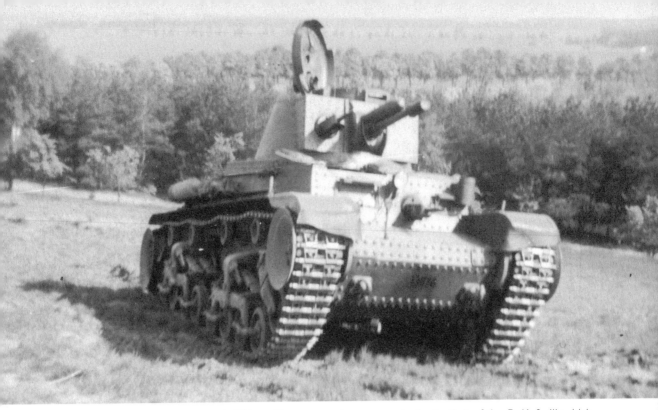

A Pz.Kpfw.35 (t) on a hillside. This tank's armament was very similar to that of the Pz.Kpfw.III, which consisted of a 3.7cm gun and co-axial 7.92mm machine gun, with a further machine gun in the front plate. The vehicles saw much use in Poland and fought a number of successful engagements.

German forces advance on the Vistula. Here soldiers converse with each other in front of a stationary Pz.Kpfw.35 (t). Before the Vistula the Germans committed its main forces in marginal, wholly unspectacular clearing operations, preparing to the front between the Vistula and Bug. In executing the last breakthrough for the river, the Germans used tightly concentrated infantry and artillery to breach enemy positions. Panzers stayed out of sight until an opening was ready, and then went straight through attacking without bothering about its flanks.

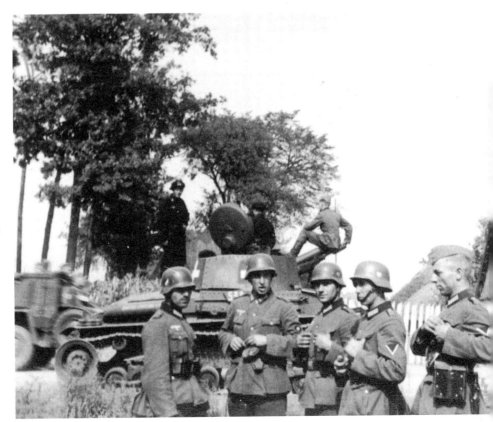

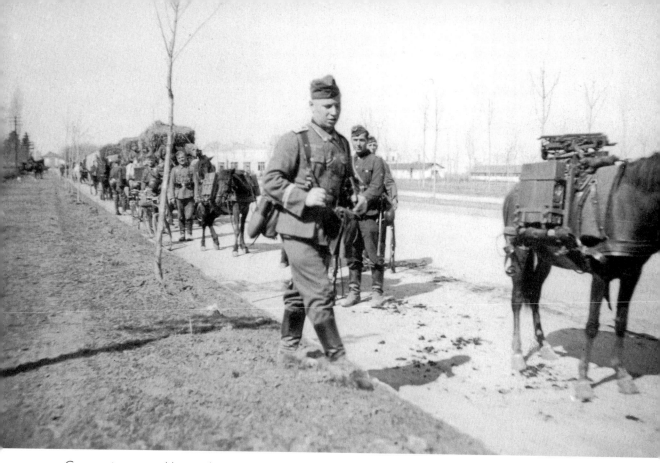

German troops and horse drawn transport halt on a road. During the night of 8 and 9 September troops of Blaskowitz Eighth Army had tried desperately to maintain contact with Tenth Army's furious advance from its rear. Eighth Army troops that were pushing east of Lodz and in the direction of the Bzura River were gradually left trailing behind in the dash for Warsaw.

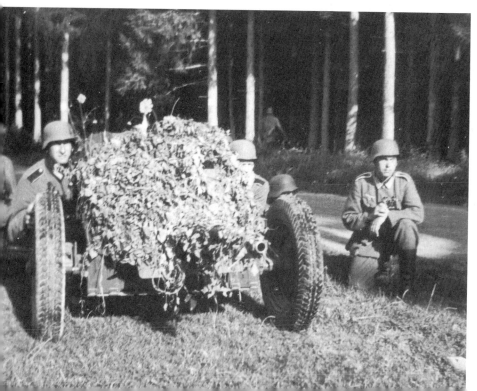

A well camouflaged PaK35/36 anti-tank gun is moved into position along a road near a forest. As troops of the Eighth Army approached the Bzura Polish forces belonging to General Kutrzeba`s Army disrupted them. Kutrzeba had a rare advantage to use infantry, artillery, sixty-five tankettes and armoured vehicles, without the worry of German tanks hampering operations.

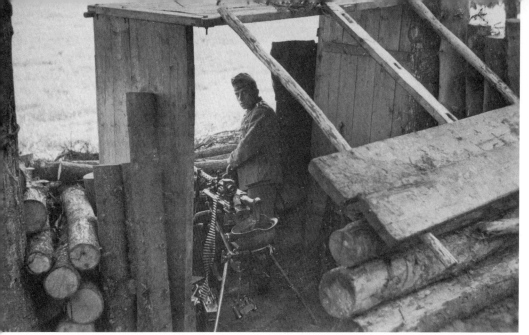

A well positioned MG34 machine gunner on a sustained fire mount. Late on the afternoon of 9 September Kutrzeba's forces attacked the German 30th Infantry Division and the 26th Infantry Regiment defending the town of Leczyca. The heaviest fighting took place at Piatek, but the Poles failed to achieve any advantage in the town.

German troops advance through a forest at dawn during heavy fighting against Polish forces near the Bzura. Fighting in the area near the town of Piatek became so fierce that German troops belonging to the 26th Infantry Regiment began to flee across open fields heavily infested by Poles. In the vicious fighting that took place most of the German NCOs and officers were killed or wounded. At times it seemed likely that General Briesen's 30th Infantry Division would regain control of the area. But the situation was not consolidated and the division retreated under a hail of shelling.

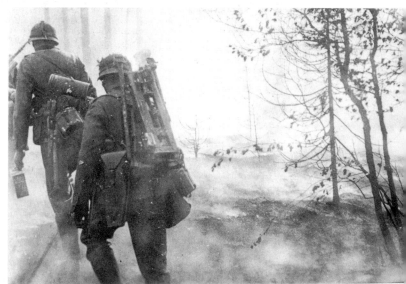

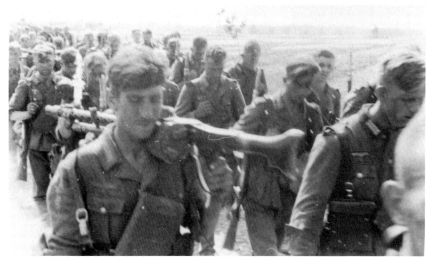

German infantry march along a dusty road towards the Bzura. Note the soldier with an MG34 machine gun slung over his shoulder for ease of carriage. The MG34 was used extensively in Poland and was the world's first general-purpose machine gun. The weapon possessed a wooden shoulder stock, pistol grip and a V-notch rear sight. The solid construction stood the test of combat and was used throughout the war.

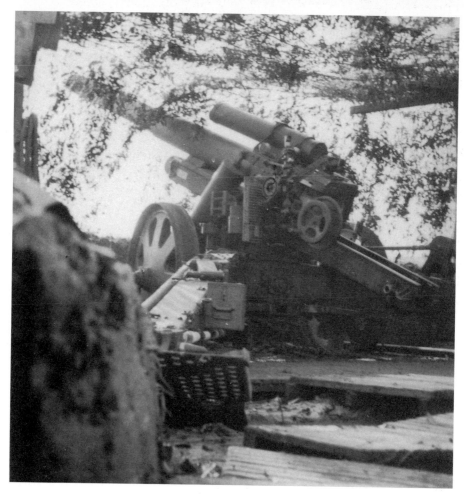

Two photographs showing a 15cm gun. As the standard German heavy field howitzer in Poland, the gun was very effective at clearing heavily concentrated enemy positions and allowing German infantry and armour to pour through relatively unhindered.

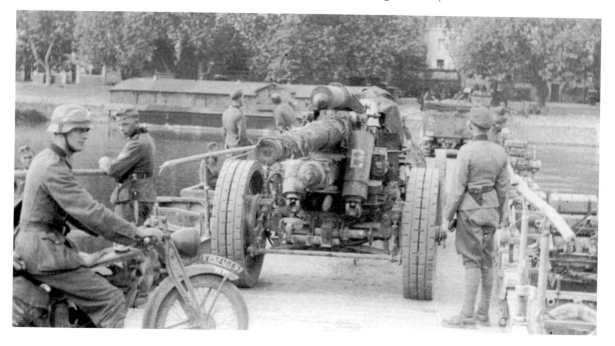

Four photographs showing the Pz.Kpfw.I. In total there were five Panzer divisions deployed against a brave but badly equipped, out-of-date Polish army. Their cavalry and mechanised units were clearly no match even against the Pz.Kpfw.I.

During the course of the campaign the Panzers showed their worth and mastered the local terrain. The Poles fought courageously, but the outcome was almost always settled by the superiority of the Panzer skills and techniques.

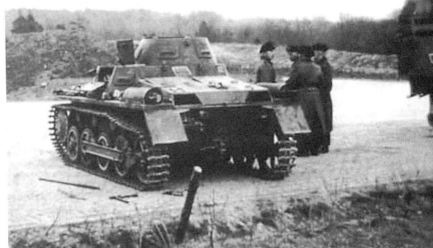

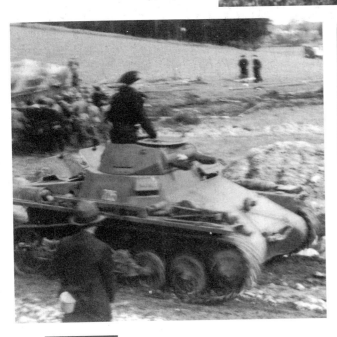

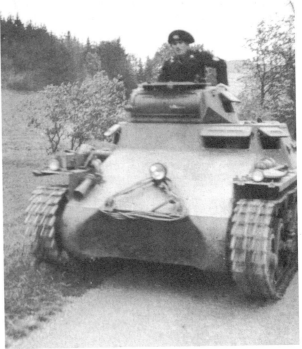

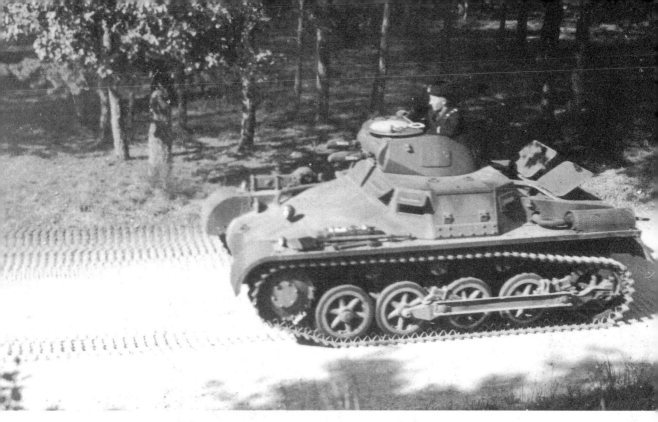

Two photographs taken in sequence showing an impressive sight of Pz.Kpfw.Is advancing along a road. The vehicles are moving in close formation, clearly indicating that air domination has been achieved.

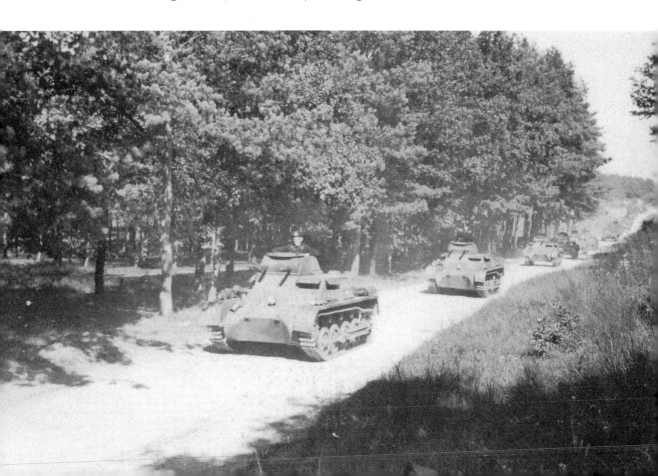

Three nice photographs showing crewmen with their Pz.Kpfw.I. During the Polish invasion both the light and heavy tanks used strength and momentum to break through the enemy line and head for vital objectives deep within enemy territory.

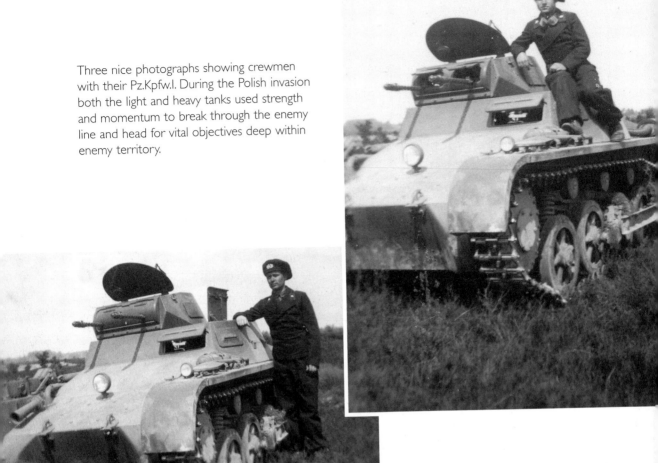

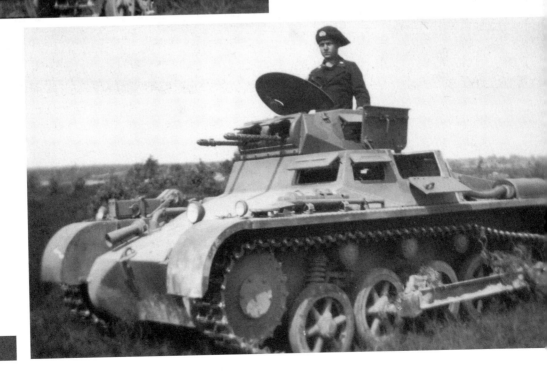

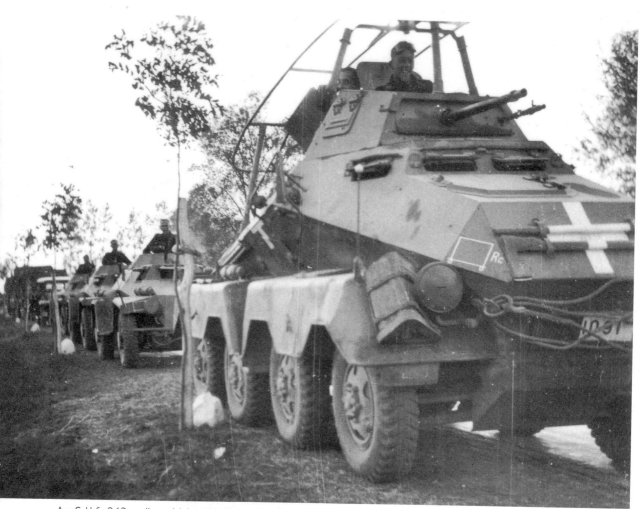

An Sd.kfz 263 radio vehicle with three Sd.Kfz.221 light armoured cars parked on the side of a road near the battered town of Sochaczew on 9 September. These vehicles belong to Hitler's foremost fighting machine, the 1.SS.Leibstandarte-Division, which supported the 4th Panzer Division's advance on Lodz.

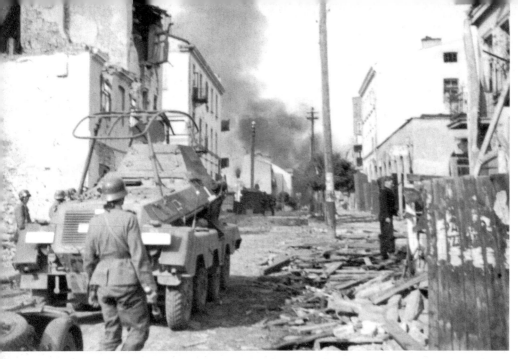

Three photographs showing infantry and SS during bitter fighting for the town of Sochaczew.

Fighting around the town was particularly fierce with many casualties from both sides. German armoured vehicles, which were trying with varying degrees of success to batter their way through the town, but were easy targets to well concealed anti-tank gunners. As a result a number of them were lost in the battle.

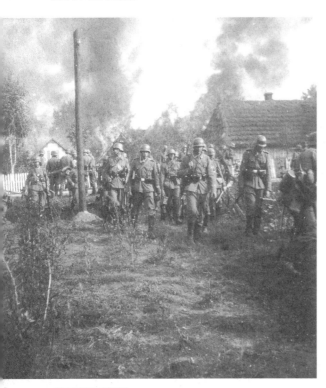

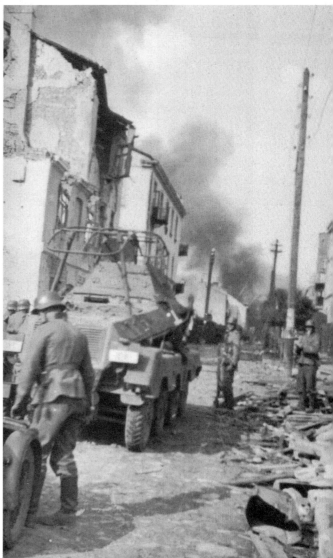

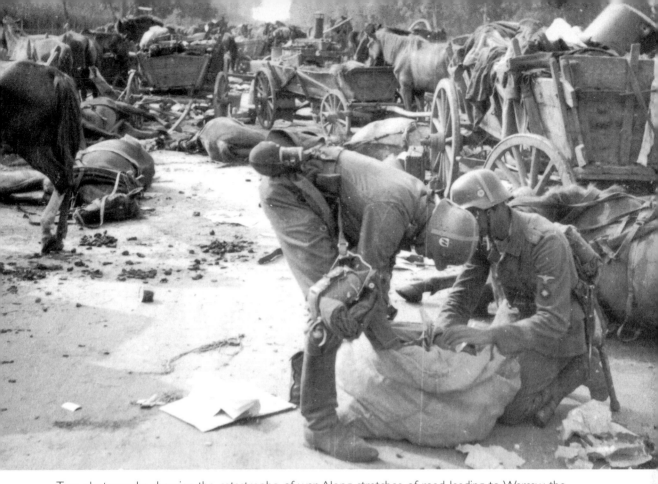

Two photographs showing the catastrophe of war. Along stretches of road leading to Warsaw the area was littered with death and devastation from heavy fighting. Damage was severe in many areas west of the Polish capital and the loss of life to both soldiers and civilians were very high. Amongst the carnage of twisted and damaged wagons are dead horses. In above photo two SS soldiers can be seen sorting through a bag.

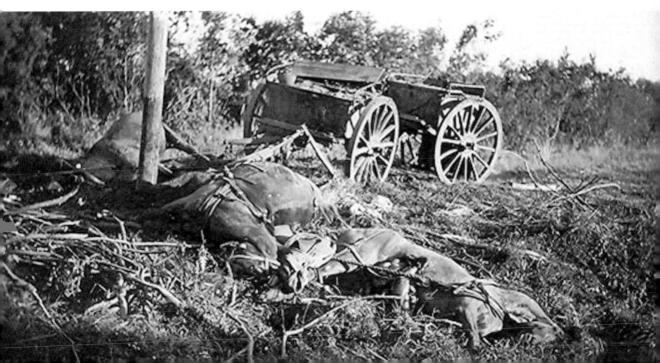

A motorcyclist belonging to a motorcyclist messenger platoon. The rider is clearly wearing his rubberised leather coat, his M1935 steel helmet and aviator goggles. The motorcycle messenger platoon was a vital asset to a Panzer division and enabled the officers and staff to receive and dispatch vital information on the battlefield.

Various German vehicles can be seen halted in a field along with infantry. This unit is resting, poised to continue its advance on the river Vistula. Despite heavy fighting along the Bzura after ten days of almost continuous fighting the Polish Army were dying a lingering death. Their supplies were too insufficient to prolong the war effort any longer.

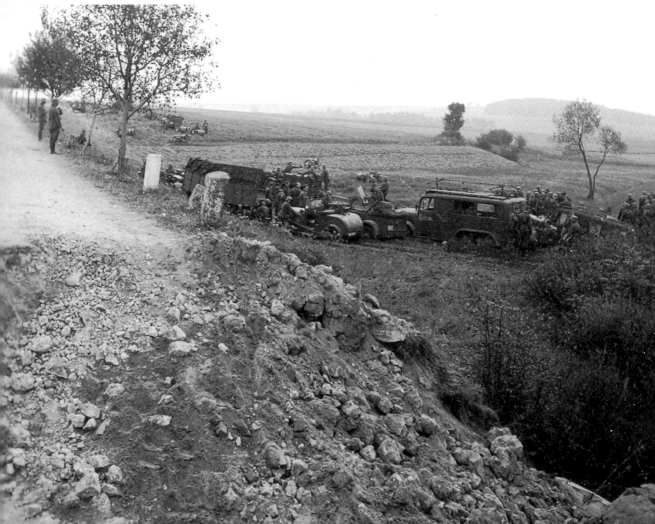

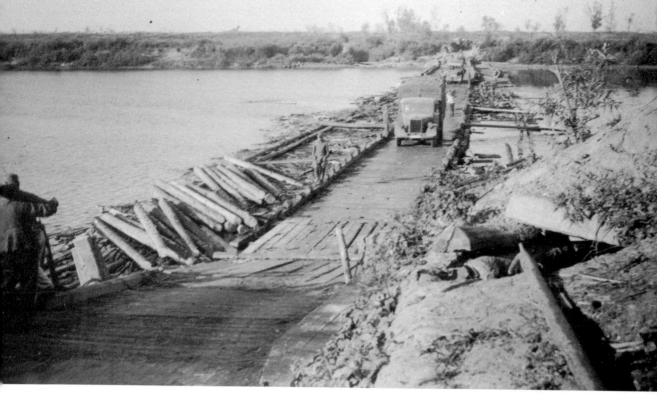

Support vehicles move across a newly constructed wooden bridge over the Bzura River bound for the front line. A huge amount of supplies were brought to the Bzura region during this period. Fighting was very intense indeed, and in some sectors of the front it required huge amounts of ammunition.

A nice photograph of an SS artillery crew firing a camouflaged 15cm s.IG 33. These SS troops belonged to the 1st SS Division Leibstandarte SS Adolf Hitler Motorized Infantry Regiment, which was attached to the Eighth Army.

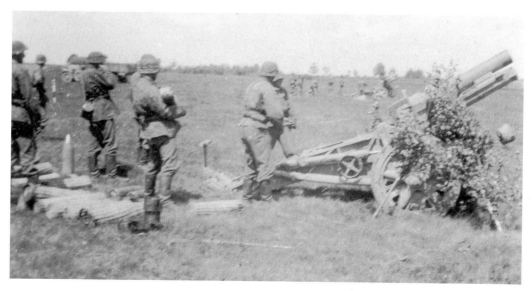

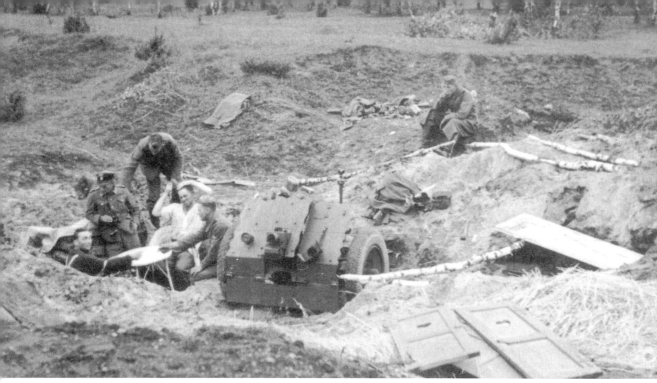

An SS artillery crew of a 7.5cm le IG 18 gun can be seen dug in. For military operations in Poland, 18,000 men were used and distributed between the Totenkopf (Death Head), Leibstandarte, and certain V-T battalions Verfügungstruppe (Combat Troops), known later as the Waffen-SS (Weapon-SS).

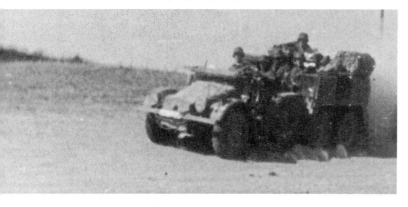

An SS armoured vehicle towing what appears to be an anti-tank gun hurtles along a dusty road bound for the front lines. In Poland the SS only consisted of a few regiments. The major part of these was transported prior to the invasion to East Prussia where they were organised into regimental combat groups which were attached to larger army formations.

A group of local people from a village watch the procession of armoured vehicles including Pz.Kpfw.Is. These vehicles are making a determined drive towards the Narew River. Whilst fighting still raged on the Bzura and Vistula rivers, both the German Fourth and Third armies made a series of combined attacks across the Narew River.

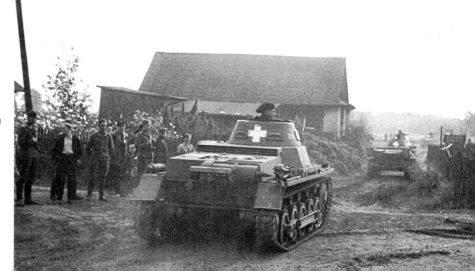

Chapter Four

Disintegration

On 12 September the dispirited and confused commander-in-chief of the Polish Army, Marshal Rydz-Smigly, ordered the general withdrawal of the entire Polish Army, which was now divided into the Polish Northern, Central and Southern Groups. These exhausted and dishevelled soldiers were now to retreat to the most south-eastern parts of the country and attempt to hold positions until the launching of a French offensive that was expected in six days. Their retreat had not degenerated into panic flight. It was a kind of stubborn retreat. Villages and towns in the objective area were strongly held by a mixture of Polish troops and partisans. German infantry sometimes had to batter their way through street by street against heavily motivated enemy soldiers. On occasions the fighting was so close and fierce it often became impossible to distinguish friend from foe. At times this stiff opposition and the continuous nature of the fighting made many German troops hard-pressed to continue what they saw as their 'legendry march'. To make matters worse brutal guerrilla warfare had broken out in many places and nervous German soldiers were unable to deal with the problem without over-reacting. If shots were fired at them from a village in bandit country, houses were torched, villages were razed, and the inhabitants, innocent as well as guilty, found themselves facing firing squads. Just as serious were the numerous occurrences of surrendered Polish soldiers in uniform being shot by regular German soldiers. However, more sinister activities were already generating fear and terror in the rear areas of Poland. Behind the military arm of the SS-VT (later Waffen-SS) and the German Army, lurked the SS Death Head groups or Totenkopfverbande under the notorious command of Theodor Eicke. Three regiments had been deployed, SS Oberbayern, Brandenburg, and Thuringen. Eicke's men quickly gained a reputation, and in a matter of days began eradicating by means of torturing and killing Poles which were regarded hostile to the Reich.

The German Army were fully aware of the systematic campaign of slaughter in the rear areas. Regular soldiers and commanders that had not been involved in these actions became increasingly uneasy and concerned. A number of them actually complained bitterly to their superiors, but nothing was done to stop the killing. As a direct result the German army's reputation, along with parts of the military arm of the SS, had been severely damaged by the Death Heads and later the five SS Einsatzgruppen (Task Force).

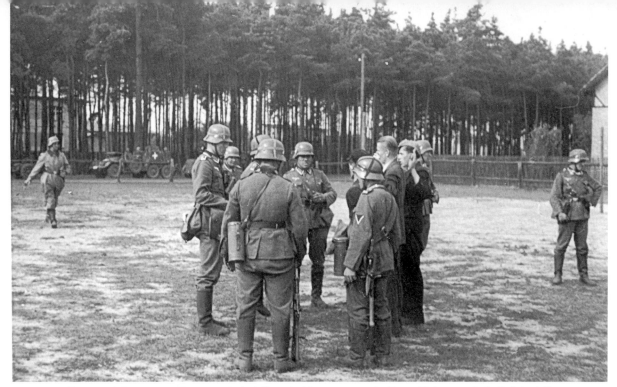

German infantry question arrested civilians inside a captured village. Quite regularly Polish civilians who were suspected of aiding the growing partisan force in Poland were rounded up, and those found guilty were indiscriminately shot.

Whilst Eicke's Death Heads and the SS Einsatzgruppen roamed Poland killing, murdering and pillaging, the German Army continued driving east using devastating blitzkrieg tactics to gain rapid supremacy on the battlefield. By 15 September German forces had reached the cities of Brzesc and Lwow. During the days that followed both these cities and the area around the Bzura became the key strategic focal point of destroying the last remnants of the main Polish Army. In addition, attention was devoted to the capture of Warsaw, which had been declared by the Poles as a fortress.

On the Bzura Kutrzeba's army constantly threatened to break out of what was now known as the Kutno Pocket to the north, but were barely able to maintain cohesion against stiff German attacks. East of the pocket, soldiers from General von Weichs XIII Corps made fierce retaliatory attacks against enemy positions defending the town of Kutno. Following a day of strong German battery-fire, accompanied by overwhelming infantry charges, a number of street battles broke out and the town finally capitulated on the 16 September. Elsewhere on the Bzura Kutrzeba's army continued its death agony to make one last attempt to smash its way through enemy lines and reach the fortifications at Modlin or Warsaw.

Inside the Polish capital General Rommel's Polish Army, which had been given the task of organising the defence of the city, still stood resolute. General Blaskowitz who

had taken charge of seizing the capital, remarked blatantly about the Poles stubbornness to capitulate: 'What shocked the most hardened soldier was how at the instigation of their military leaders a misguided population, completely ignorant of the effect of modern weapons, could contribute to the destruction of their capital'.

Hitler was so eager to see Warsaw surrender he even made a special visit to the front line around the city on 16 September. On board Hitler's special headquarters train, the 'Führersonderzug', the Führer had been plaguing his Generals for days, asking them incessantly when 'Fortress Warsaw' would fall. To keep casualties down to a bare minimum his staff favoured starving the city into submission, but Hitler wanted the capital taken as quickly as possible. Already his new found allies, Russia, were preparing to invade Poland from the East. In his secret non-aggression pact with Stalin in August 1939 they had drawn up plans to carve up Poland between themselves. Because of the establishment of the Vistula as a demarcation line with Russia, Hitler wanted the capital captured without delay and insisted on sending the Poles an ultimatum. Later that afternoon several hundred tons of leaflets were dropped from twelve Heinkel bombers, advising the civilian population to leave by two specified roads within two hours. The Poles, however, refused outright, preferring to fight on than agree to Hitler's terms.

Soldiers survey the devastation of a town after it was systematically brought under heavy shelling during a bitter battle with Polish troops. Dispirited and confused, those Poles that had not been killed in the hurricane of fire retreated.

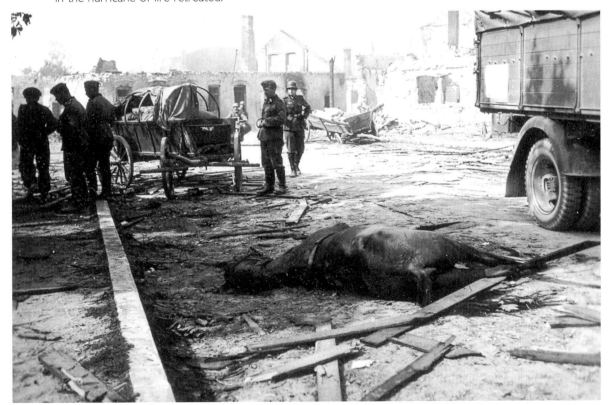

The next day on 17 September while German forces around Warsaw confined its attacks by using a combination of artillery bombardments and air raids, news reached von Bock and Rundstedt that the Polish frontier in the east along its whole length from Latvia in the north down to Rumania in the south had been attacked by the Russian Army. The Russian invasion was swift and almost immediately its forces began taking out scatted pockets of Polish resistance that consisted mainly of detachments of the Frontier Defence Corps or KOP. In the towns and villages bordering the Russian frontier, frightened and bewildered Poles dazed by the invasion stared in amazement from their windows and doorways. The invasion had come as a complete surprise. Because most of the Polish Army had either been routed or destroyed those defending in the east were hopelessly out-numbered and out-gunned. The situation for the Polish Army was now even grimmer. For them the final blow had been unwittingly delivered.

At last Hitler, the warlord, who described himself as the 'first soldier of the Reich', had achieved his plan – the wholesale destruction of Poland. His war in the east was almost complete. The German Army had recaptured Danzig; the former lands of Poznan and Silesia, the Wehrmacht were annihilating the last pockets of resistance, and its Russian allies were occupying the eastern territories that Hitler did not require. Both Germany and Russia were now accomplices in wiping ancient Poland off the map.

As the Russians thundered west, Guderian's XIX Corps, which had raced south towards Brzesc on the Bug finally made contact with General von Kleist's XXII of the German Southern Group. Virtually the whole Polish Army, or what remained of it, was now trapped inside a gigantic double pincer. The besieged city of Brzesc, which the Poles had defended at terrible cost, finally capitulated and Guderian established his headquarters in the city. In the south, infantry and Panzer divisions from List's Fourteenth Army encircled the heavily fortified garrison defending the city of Lwow on the San.

Elsewhere, west of the Vistula and San, the Wehrmacht were mopping up pockets of resistance by-passed during the great dash for the rivers. Around Warsaw, infantry divisions from Third, Eighth and Tenth armies were able to impose a decisive block on the cities perimeter and prevent the bulk of enemy forces escaping into the besieged capital. On the Bzura the town of Kutno fell with the capture of 40,000 Poles. Despite stiffening superiority and unrelenting fire power, the remains of Kutrzeba's encircled army continued to fight for the death, doomed in the fiery cauldron that the Bzura had become. The resilience and the chivalry shown by the Poles on the Bzura had caused genuine surprise among the German troops, even amongst some of the most irrepressible SS soldiers.

By 18 September, besieged by an ever increasing flow of infantry and tanks from

the bulk of Tenth Army, massive parts of Kutzeba's force finally laid down its arms. General Hoepner's 1st and 4th Panzer Divisions had captured a staggering 80,000 prisoners and a large amount of battlefield booty. In other parts of the pocket a number of divisions from Blaskowitz Eighth Army eliminated the last remnants of resistance in the area. In all some 90,000 troops, 320 guns, 130 aircraft, and an enormous amount of equipment were captured by Blaskowitz army. German soldiers were completely stunned by the weight of the blow which had hit the Bzura region. Following nine gruelling days of combat the battlefield had become wrought with death and destruction. Both banks of the river were covered with the dead and carnage of war. Never before had these young German soldiers seen so much catastrophe. Many of them could not help but to gaze at the scarred Bzura skyline, virtually all the familiar landmarks were almost unrecognisable.

The battle of the Bzura resulted in the total destruction of nearly a quarter of the Polish Army. It was the only major Polish counter-offensive of the campaign and the largest single action, involving over fifteen German divisions, including two of the most powerful Panzer divisions, and three light divisions, against some nine Polish infantry divisions and two cavalry brigades.

The German march through Poland had taken no more than eighteen days to achieve. By this time the Germans had moreover swept every Polish division clean off the map, brought thundering Panzer divisions to the very far corners of eastern Poland and outflanked and outmanoeuvred its opponents with skill, verging on brilliance. The days that followed consisted of a series of actions against the last remnants of the Polish Army.

A line of Pz.Kpfw.IIIs have halted in a field using some the of trees and foliage to help conceal their vehicles. Despite the victorious spearheads of the Panzers the Polish retreat had not degenerated into panic, despite the pulverising effects of the enemies Blitzkrieg tactics.

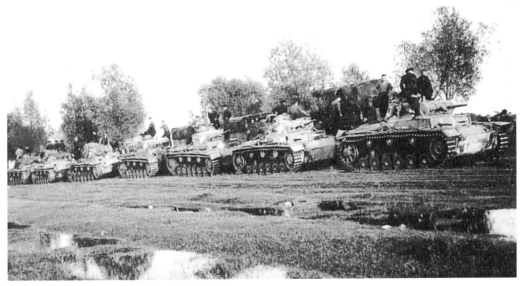

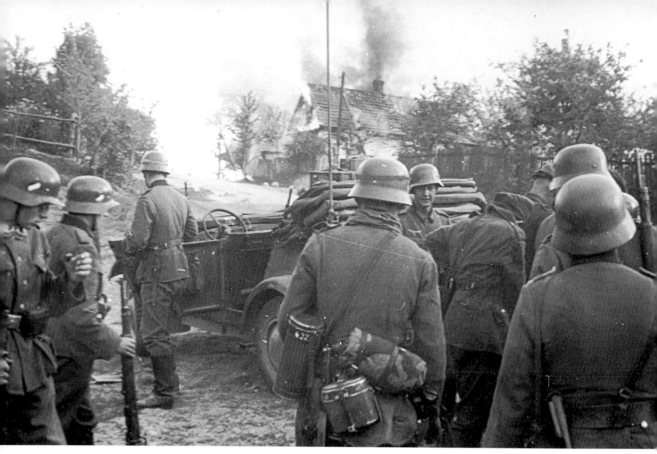

Troops inside a captured village that has just fallen into German hands. Note the Polish prisoner being escorted away. The swiftness of the German advance was a huge psychological shock to the Poles, and they did well to muster any sort of defence.

A column of Pz.Kpfw.38 (t)s advance through a field, trying to avoid the congested roads east. As the Polish Army began to disintegrate villages and towns in the German objective area were beginning to be held by a strong mix of Polish troops and partisans.

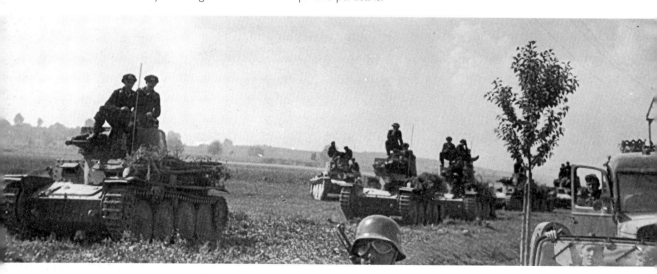

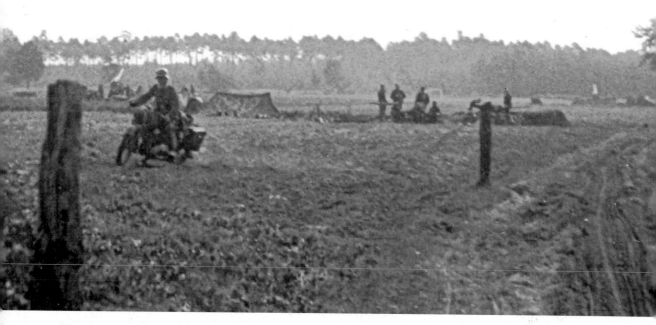

Troops can be seen encamped inside a field with tents. A motorcyclist is moving across the field towards a muddy road probably preparing to escort the approaching vehicle.

An officer questions a Pole who is seated in the passenger seat of a staff car whilst two motorcyclists watch and listen. Throughout the German advance many Polish civilians and troops were interrogated in order to find out additional information on the whereabouts or location of enemy positions. Courtesy of Jim Payne

At a divisional headquarters German commanders are seen going over various maps and other pieces of information. Courtesy of Jim Payne

A radio vehicle advances through a village. This armoured vehicle is equipped with a long range radio set and was used mainly by signal and Army headquarters. Even during the later part of the invasion a number of vehicles still displayed the prominent white cross on the side.

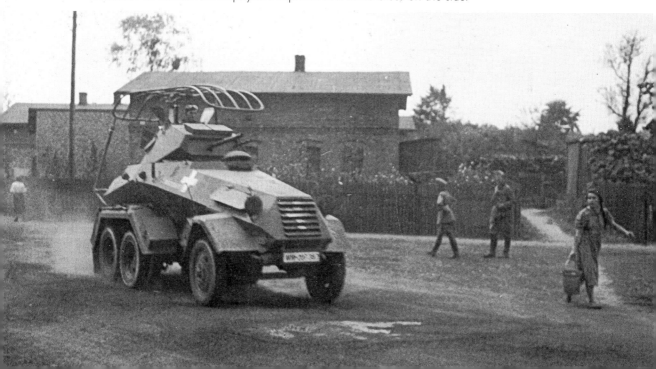

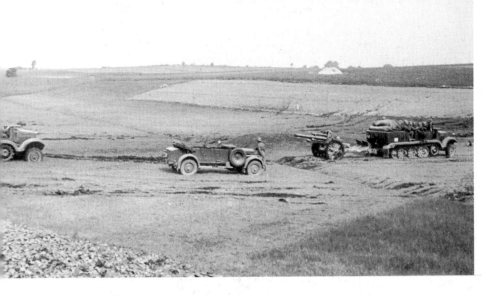

Two halftracks move across a field passing a stationary vehicle. The leading halftrack is towing a 10.5cm artillery gun. This weapon was the standard light howitzer used by the German Army in Poland. Many of these weapons were brought to the outskirts of Warsaw and used to soften up Polish defensive positions within the city limits. Courtesy of Jim Payne

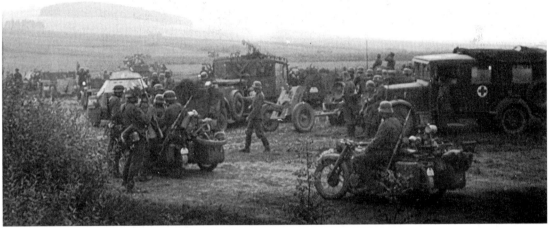

Two photographs showing various armoured vehicles, support trucks and motorcycle combinations out in a field. By 10 September the Polish Army had all but been vanquished. There remained for the Germans the 'Second Phase': crushing the dazed and disorganised Polish units, and destroying them, before completing a much deeper, envelopment aimed at the River Bug, 125-miles east of Warsaw. Courtesy of Jim Payne

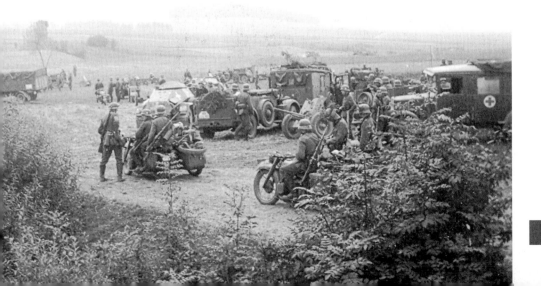

Two photographs showing light Horch Country vehicles, motorcycles and support lorries. All these vehicles were a vital contribution to both the infantry and Panzer divisions that were operating deep inside Poland. Maintaining the advance was very important to the success, and supplying the divisions, especially when leading units were far ahead of its column were of utmost importance. Courtesy of Jim Payne

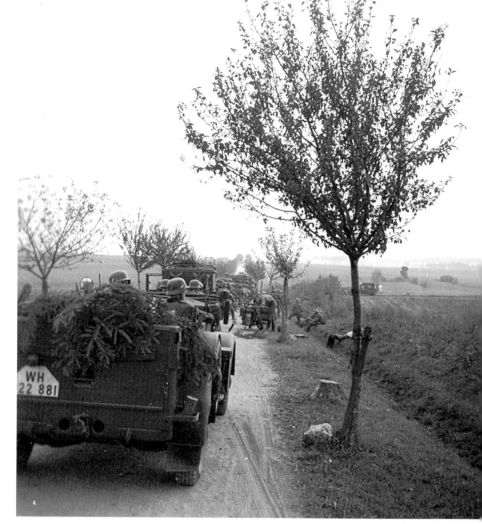

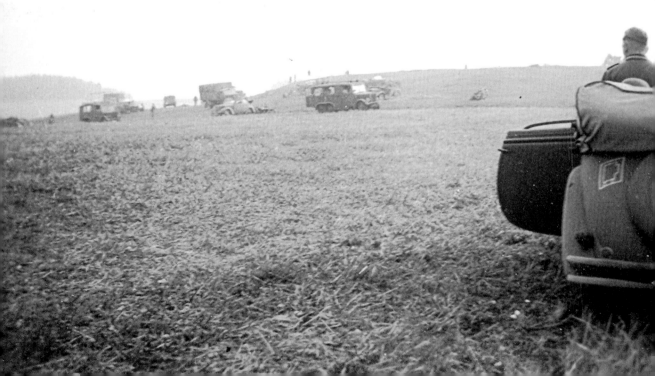

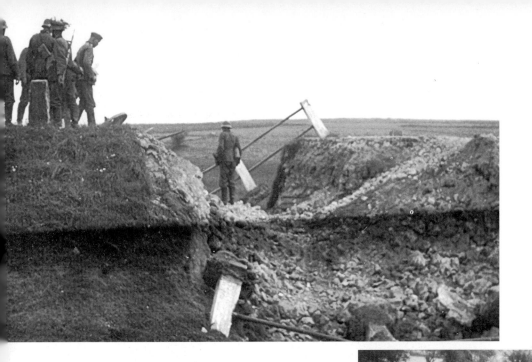

Three photographs show engineers at work repairing a road that was more than likely destroyed by the Luftwaffe during the early part of the campaign. Moving an armoured force by road was an immense undertaking, especially when considering that a normal armoured column occupied nearly 70-miles of road space at any one time. Courtesy of Jim Payne

German vehicles have halted on a road before entering a village. A local man watches the spectacle from the roadside. Driving along the narrow, rutty roads in Poland was always difficult, but was made particularly worse for the soldiers with increasing partisan activity. *Courtesy of Jim Payne*

A group of soldiers pose for the camera next to a river with their inflatable boat. To ferry men and equipment, the soldiers used inflatable boats more than capable of carrying anti-tank guns or small infantry howitzer.

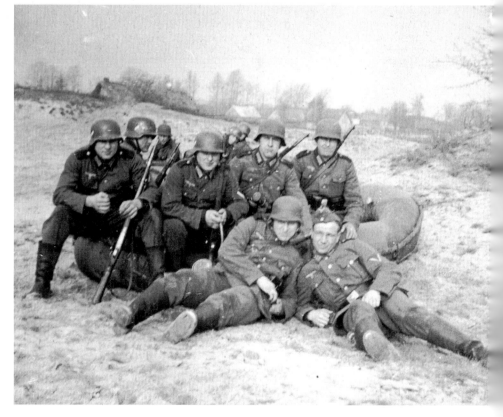

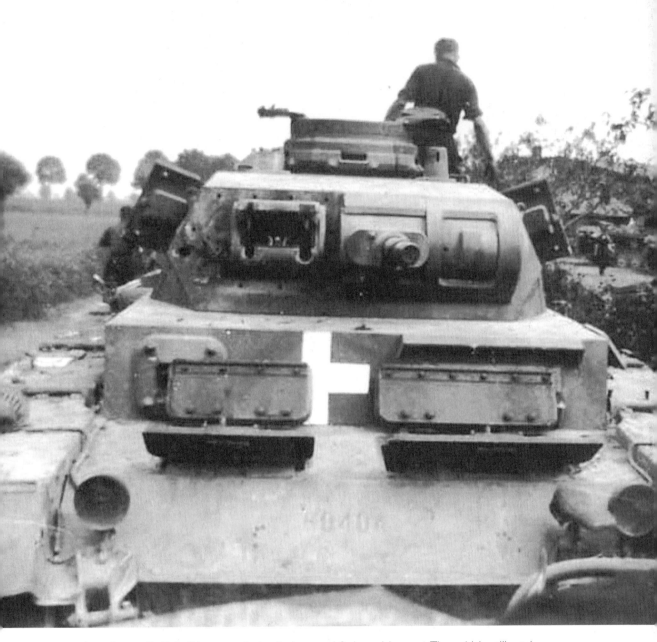

A stationary Pz.Kpfw.IV pauses during its long and furious drive east. The vehicle still retains the white cross. The Pz.Kpfw.IV became the most popular tank during World War Two and remained in production throughout the war. At first it was not intended to be a main armoured vehicle in the Panzerwaffe, but in Poland and then against the west it soon proved to be a diverse and effective weapon.

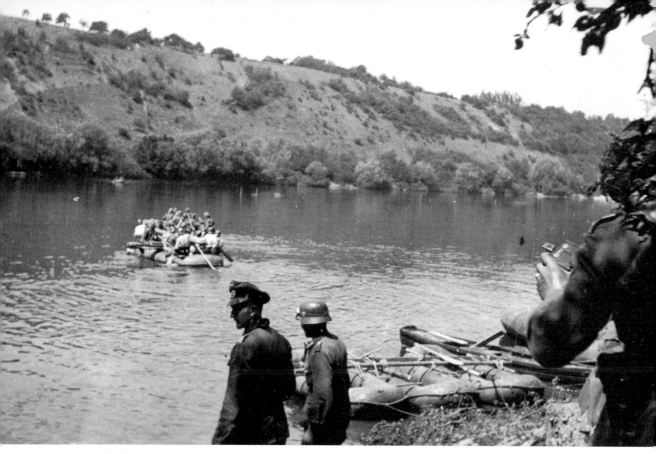

Inflatable boats have been pressed into service by assault troops. Two paddles either side was normally sufficient enough for the boats to be propelled through the water, even when carrying a full complement of infantry onboard with heavy weapons and equipment.

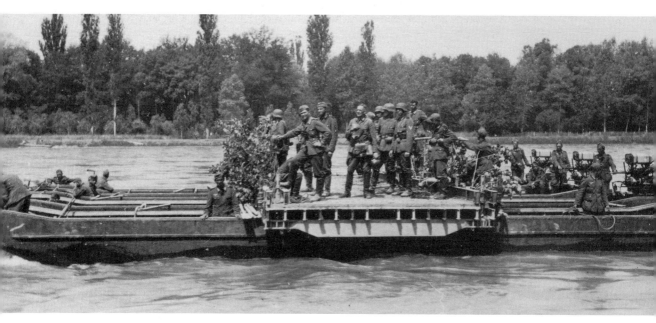

Engineers with a pontoon section ferrying troops across a river bound for the front line. The German drive through Poland continued with rapid succession. Instead of attempting to outflank the Poles and envelop him, they sought to use the weight of the Panzer division to break through the enemy line and head for objectives deep in the enemy rear.

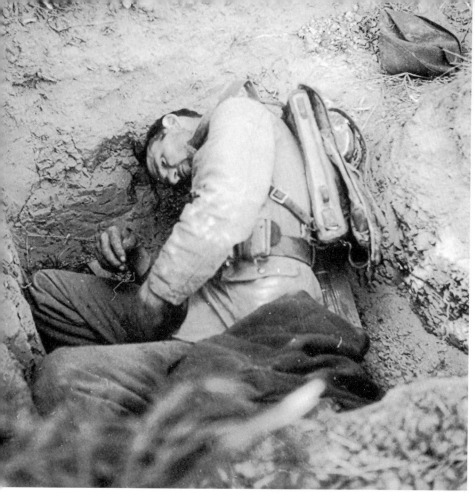

Two gruesome photographs revealing two dead Polish soldiers shot whilst trying to defend their meagre position. Although it is difficult to estimate just how many Poles were killed, it is known that some 800,000 men were mobilised by the Polish Government during the course of the campaign, a total of 694,000 were captured. The remaining 106,000 men were either killed in action, forced to flee across into Romania, or captured by the Red Army when it invaded on 17 September 1939. Courtesy of Jim Payne

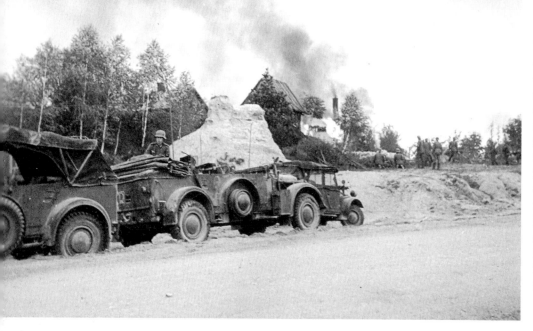

Vehicles have halted on a road. In the distance black smoke rises into the air, more than likely caused by heavy shelling of the area. Over the next days that followed exhausted Polish troops continued to laboriously stream eastwards through the closing jaws of the German pincer.
Courtesy of Jim Payne

German troops more than likely belonging to the Eighth or Tenth armies have halted in a small village with their vehicles west of Warsaw. In the distance unmistakable signs of heavy fighting are apparent as smoke raises high into the air following a heavy aerial attack on the area. Courtesy of Jim Payne

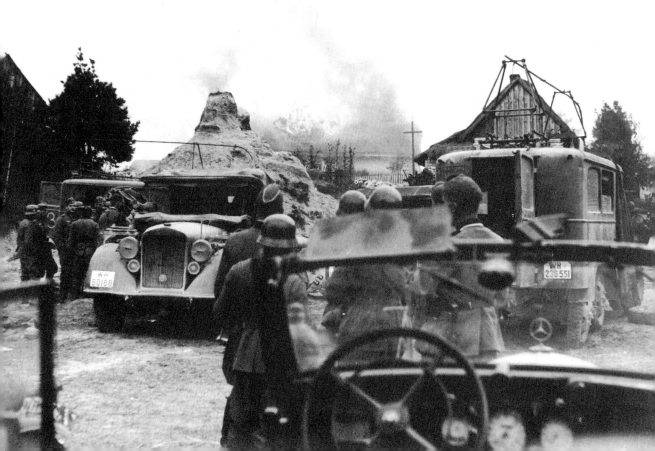

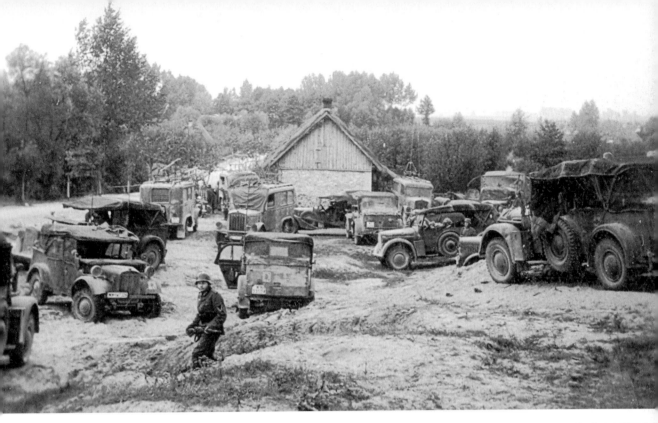

A variety of Horch Cross Country vehicles have halted near a building. Much of the German advance was now unhindered. The Polish Air Force was barely making any serious contact against German armoured columns due to the severe lack of fuel. Courtesy of Jim Payne

German infantry move slowly forward towards the outskirts of a village. After more than two weeks of continuous fighting, marching across many miles of unknown territory and sometimes faced with well-defended positions, which took a variable amount of time to conquer, German soldiers were occasionally hard pressed to continue and some were on the verge of total exhaustion. Courtesy of Jim Payne

Meticulous planning was very important for any military campaign and the Polish invasion was no exception. Here German commanders study maps and other important data.
Courtesy of Jim Payne

Troops belonging to Eighth Army west of Warsaw. On 14 September both the Eighth and Tenth armies helped to secure the encirclement of Kutrzeba's Army and prevent any attempt made by the Poles to break out east and join the Modlin and Warsaw garrisons.

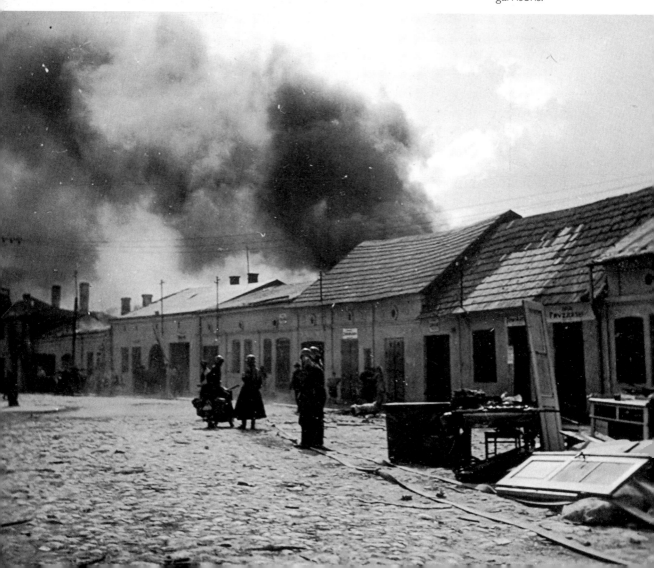

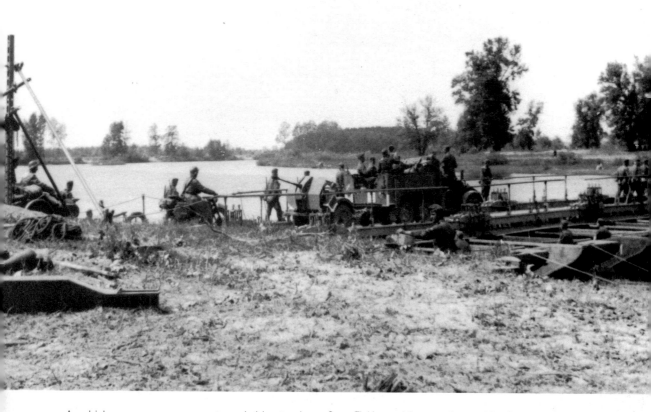

A vehicle passes across a pontoon bridge towing a 2cm FlaK gun. Motorcycle combinations can be seen following closely behind. The 2cm FlaK gun was the first anti-aircraft gun to see active service in the Wehrmacht.

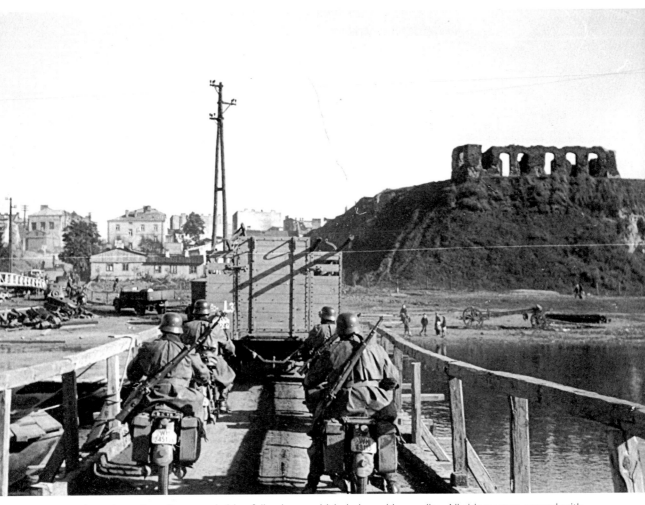

A motorcycle unit cross a bridge following a vehicle laden with supplies. All riders were armed with side arms or Mauser rifles slung over their shoulder. Supplies were attached to the back of the bike on panniers.

Chapter Five

Capitulation

On 18 September General Guderian officially surrendered the city of Brzesc to the Red Army, since the agreed boundary-line drawn-up between Germany and Russia was the Vistula-San line. A farewell parade and salutes to the two flags in the presence of the Russian Brigadier-General Krivochin and Guderian marked the end of the German stay in the city, whose capture had cost so much blood.

Three days later in the south the Russians appeared outside Lwow and List's Fourteenth Army was ordered to withdraw its forces from the besieged city and surrounding areas. The planned attack by Baier's XVIII Corps against the city was cancelled and the corps prepared to pull out. Abruptly and unexpectedly, after days of heavy fighting the Polish commander, General Langner, surrendered his Lwow garrison of 120,000 troops to Kubler's 1st Mountain Division, rather than give up his command to the Russians. The occupation of the city was left to the Red Army, whilst the 1st Mountain Division and XVIII Corps moved out of Lwow and headed west.

On 25 September while a number of heavy attacks were made north of Warsaw against Polish forces defending the Modlin fortifications, the Polish capital came under the heaviest aerial bombardment of the campaign. As 400 bombers, dive bombers and group attack aircraft, supported by 30 tri-motor transport planes pounded the city, Hitler from the roof-top of a sports stadium watched with binoculars the unfolding air raid.

Early next morning following another refusal by the Poles to surrender Warsaw, troops and armour of Eighth Army stormed the city and began taking the capital street by street. Slowly the Warsaw garrison began to disintegrate under the massive ground and artillery attack. By next day German assaults had reached such a level of intensity that the Polish commander General Rommel decided to capitulate than to endure a further day of blood-shed. In total 140,000 Polish soldiers, more than 37,000 of them wounded were taken into captivity.

After the fall of Warsaw numerous other engagements, some of them still quite heavy, continued to rage. On 29 September, the Polish garrison defending the Modlin forts finally surrendered to SS Division 'Kempf'. A staggering 24,000 Polish soldiers, including some 4,000 casualties were taken prisoner. Throughout the rest of Poland the last remaining pockets of resistance were being rounded up.

On 1 October, while the German Army were still withdrawing its troops to the

Two photographs showing German vehicles halted on the main road to Warsaw. Due to heavy fighting in the capital and along the Bzura west of the city, many vehicles were unable to move along the congested road. Courtesy of Jim Payne

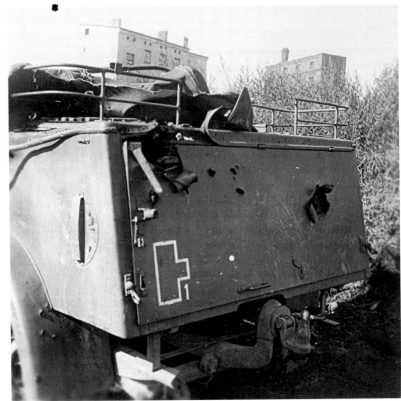

agreed Vistula boundary, the German High Command suddenly announced that the demarcation line had changed and that henceforth the line would be along the Bug down to the San to the Slovakian border. Weary troops that had trudged east and then withdrew west had to once more advance east again, meeting further Polish resistance. The most significant of these was east of the Vistula near the town of Kock. This was the last major battle of the campaign and it was not until 6 October that Kleeburg's force of 16,000 soldiers surrendered to Wietersheim's XIV Corps, signifying the end of the German campaign in the east and the final crushing of Poland.

In the light of tactical and geographical dominance, the Commander-in-Chief of the German Army, von Brauchitsch, ordered the partial demobilisation of the Northern and Southern Army Groups. Exhausted and tired, thousands of troops began its long arduous journey back to their home stations. For the Poles, defeat however came as a terrible blow. Altogether some 694,000 Polish soldiers had been captured by the Germans, whilst 217,000 of them were rounded up by the Russians. At least 50,000 Polish troops had been killed in action and as many as 140,000 were wounded. More than 90,000 Polish soldiers and a vast number of civilian refugees, including Poland's government and Commander-in-Chief of the Army, fled across the borders of Rumania and Hungary. What surviving remnants remained were now captives of a nation that hated them. Poland was in ruins and through the rubble strewn cities and towns the inhabitants stood numb and terrified, clinging to the few possessions they had left.

With the fate of Poland inevitably sealed, on 5 October 1939, amidst the destruction and stench of rotting bodies, Hitler flew to Warsaw where a victory parade was held in honour for parts of the six divisions that had taken the city. At its conclusion von Brauchitsch, von Rundstedt, Blaskowitz and other commanders took Hitler to an airfield to meet the commanders of the troops that had taken part in the parade. After swallowing a little soup at the field kitchen and exchanging a few remarks with the soldiers he made his way to his private aircraft, the Grenzmark. Just before boarding he was introduced to a group of correspondents. He then made a brief statement and said menacingly; 'Gentlemen, you have seen for yourselves what criminal stupidity it was to try and defend this city. I only wish that certain statesmen in other countries, who seem to want to turn all Europe into a second Warsaw, could have the opportunity to see as you have, the real meaning of war'.

Hitler was determined that this new conquered country would be part of his ideological and racial dream. He was going to make sure that Poland would be dismembered, subdivided, and repopulated in such a way, that it would never be able to rise against Germany again. For the inhabitants of Poland however, they were compelled to live out their lives in the hands of Hitler's plans for the next five years. The German Army, which had won Hitler his 'Eighteen day victory march', were now to observe helplessly as the country was racially destroyed by its SS counterparts.

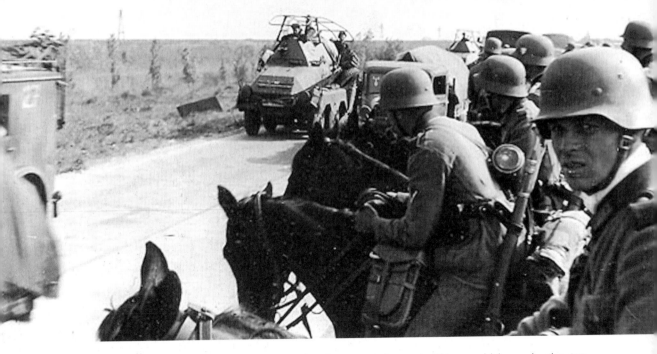

Another two photographs showing German forces on the main Warsaw highway. In the top photograph an Sd.Kfz.263 armoured radio vehicle can be seen passing a group of soldiers on horseback. Note the non appearance of the white crosses. Courtesy of Jim Payne

Horse drawn infantry halted on a road somewhere in Poland. Note the national flag draped over the horse-cart acting as a recognition flag against possible aerial attack. The drive across Poland had been so rapid that both Luftwaffe fighter and bomber crews were occasionally misidentifying their own columns on the ground.

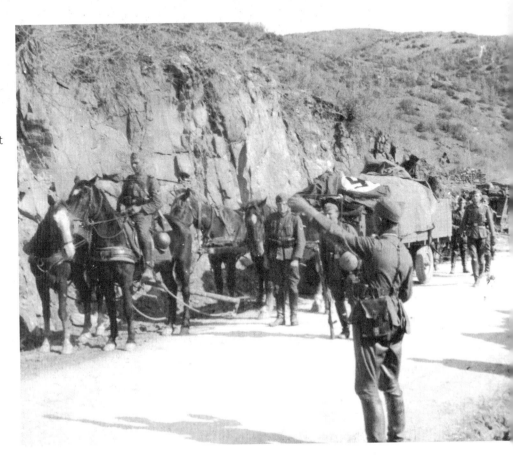

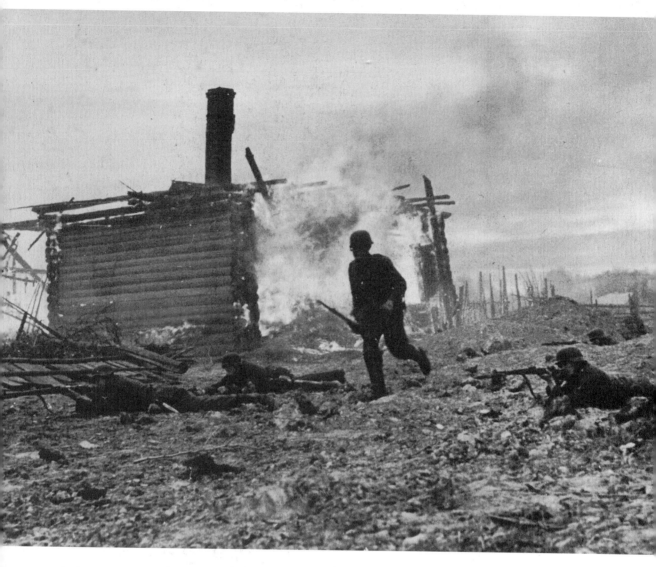

A photograph taken during what seems to be a staged infantry attack inside a burning village. During the advance through Poland there were a number photographic units that took various staged photos for propaganda, and these were widely used in publications and newsreels through Germany

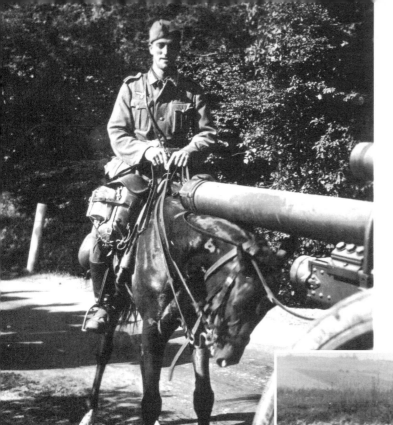

An infantryman on horseback following what appears to be a 10.5cm howitzer on tow. It was primarily the artillery regiments that were given the task of destroying enemy positions and fortified defences, and conducting counter-battery fire prior to an armoured or infantry assault.

Another photograph showing the same infantry column halted on a road next to a 10.5cm howitzer being towed by animal draught.

Two infantrymen on horseback riding along a road. Contrary to popular belief, much of the German Army in September 1939 was animal draught. Whilst Hitler preferred mechanized divisions as the most effective method of winning a war the horse played, and continued to play, a significant part in German warfare.

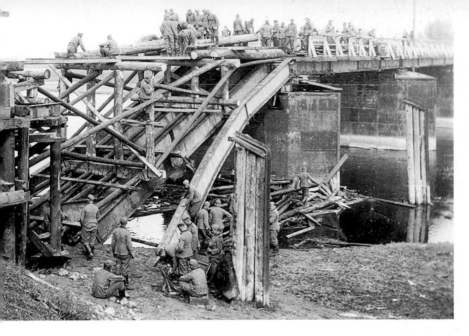

Three photographs showing bridges blown. In the photograph above engineers are repairing a damaged bridge across the Vistula. Courtesy of Jim Payne

In some places the Poles tried frantically to impede the mighty German armoured advance by blowing up as many river crossings as possible. The Poles tried to use the waterways as a defence line in the face of an attack.

Courtesy of Jim Payne

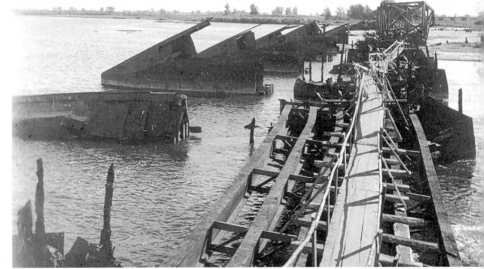

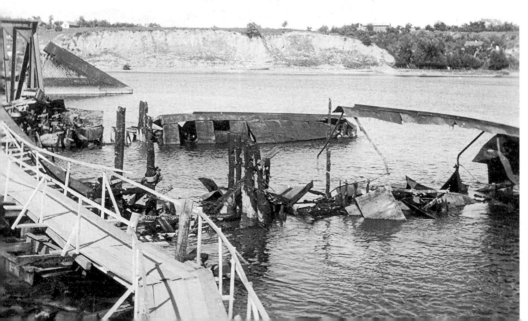

German troops can just be seen to the left of the photograph resting. By 18 September, besieged by an ever-increasing flow of infantry, tanks and the aerial might of the Luftwaffe, the Polish Army disintegrated.

A nurse carefully removes a bandage from a soldier. German troops suffered from higher casualties than expected, especially whilst trying to take Warsaw. However, with relatively good access to field hospitals and air transport the wounded could quickly be removed from the battlefield for rest and recuperation.

Two motorcyclists, one with a sidecar combination, follow a convoy of vehicles along a road. Both riders are wearing the familiar double-breasted rubberised motorcycle coat and leather gloves. They are also armed with the Mauser rifle.

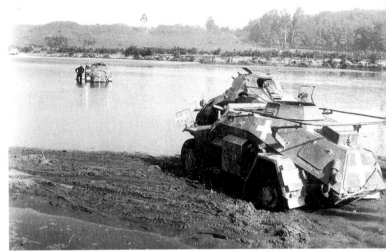

Two photographs showing armoured vehicles attempting to wade across a river. In the photograph below an Sd.Kfz.231 (6-rad) has become stuck in mud on the river's edge. Attempts by a Sd.Kfz.221 four wheeled car has been unsuccessful, prompting the arrival of an early production Sd.Kfz.263 radio vehicle. Courtesy of Jim Payne

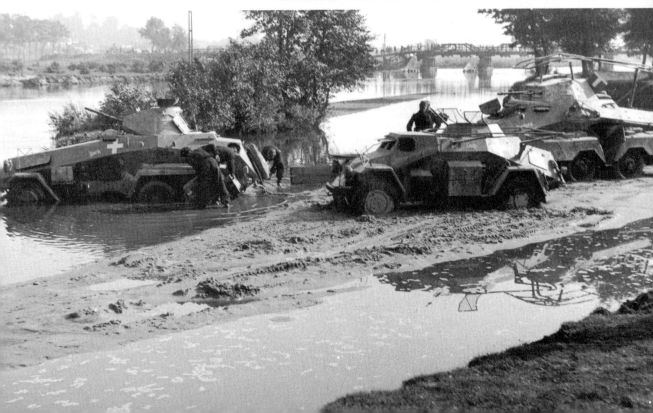

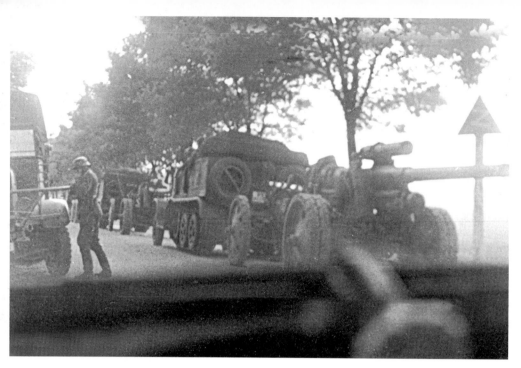

Halftracks towing 15cm howitzers toward the city of Brzesc have halted on a road. By 14 September leading elements of the 10th Panzer Division had reached Brzesc and heavy attacks had forced the defenders to withdraw into the city's fortress.

Here German forces of the 20th Motorized Division are pulling out west from the Bug River after receiving orders that the agreed boundary-line drawn-up between Germany and Russia was to be the Vistula-San line.

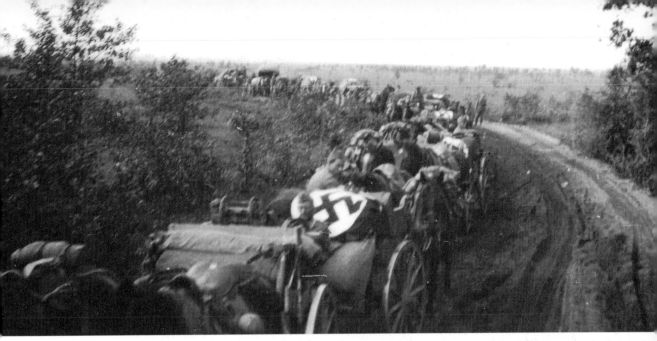

A long column of horses move along a road. Note the national flag for aerial recognition. After two weeks of the campaign much of the Polish air force had been annihilated, and those aircraft that had not been destroyed were removed to secret locations.

The extent of the damage to the town can be seen, which is a result from systematic bombing from the Luftwaffe. By the outbreak of the war with Poland the Luftwaffe had turned into a highly efficient force with up-to-date equipment.

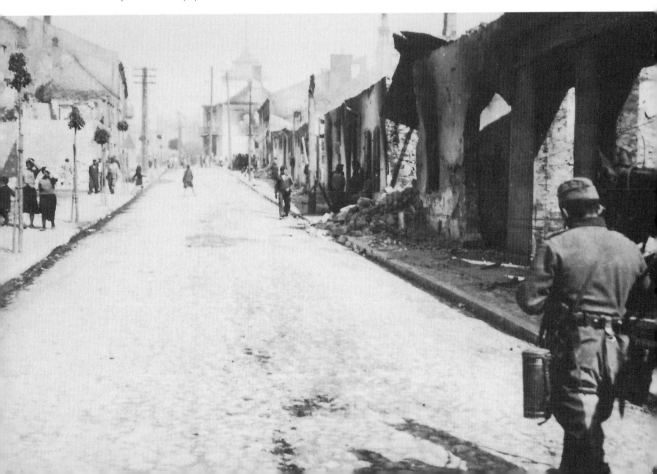

Five photographs showing Polish prisoners being led away into captivity. The very speed of the German onslaught undermined the will of many of the Polish units to fight on. By 18 September the Polish Army had totally disintegrated. With no clear orders, cut off from support and without supplies, many chose to surrender without a fight. By the end of the campaign some 694,000 troops ended the war against Germany in prison camps. Courtesy of Jim Payne

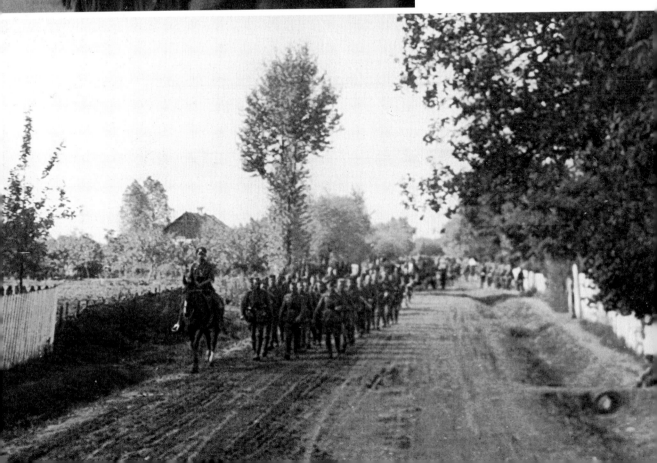

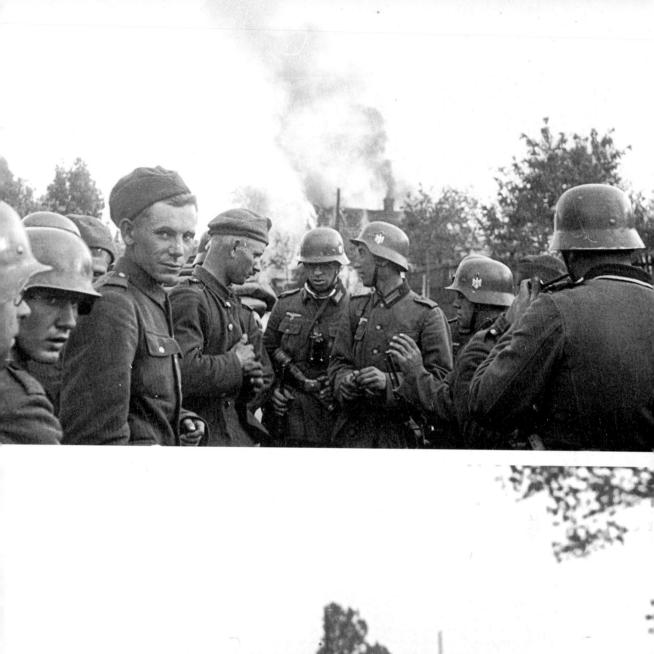
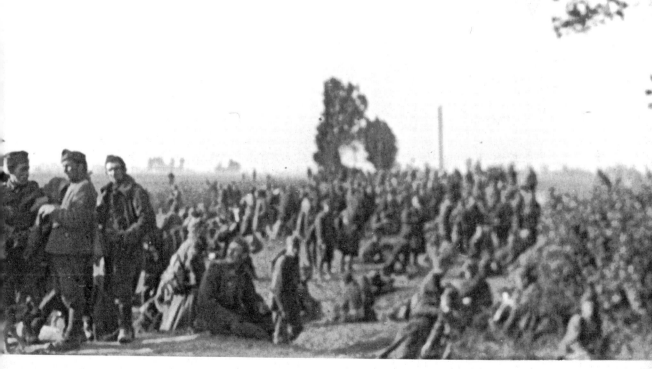

Vehicles move along a dusty road bound for Warsaw. It had been decided that any offensive against the Polish capital should be undertaken by infantry divisions of the Eighth Army attacking into the southern and western suburbs of the city.

Another halftrack belonging to the Eighth Army pushes eastwards towards Warsaw in preparation for an assault into the suburbs. Many hundreds of artillery pieces and well armed infantry were dug-in on the outskirts of the city. Over the ensuing days continuous artillery bombardments were undertaken with probing attacks into the suburbs.

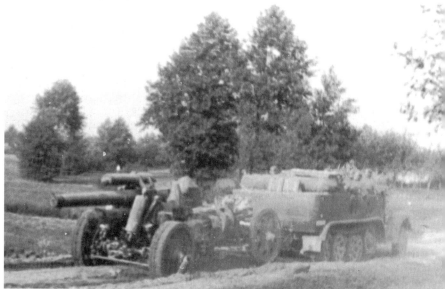

With the rapid advance of the armoured spearheads isolated pockets of Polish resistance were often bypassed, leaving them roaming in forests. Here a German unit undertaking a 'mopping up' operation has halted inside a forest and captured a number of Polish stragglers.

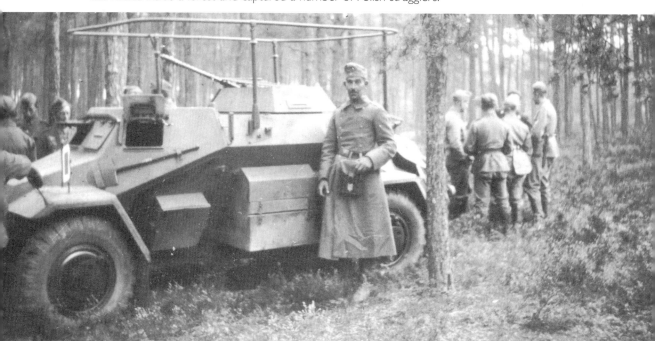

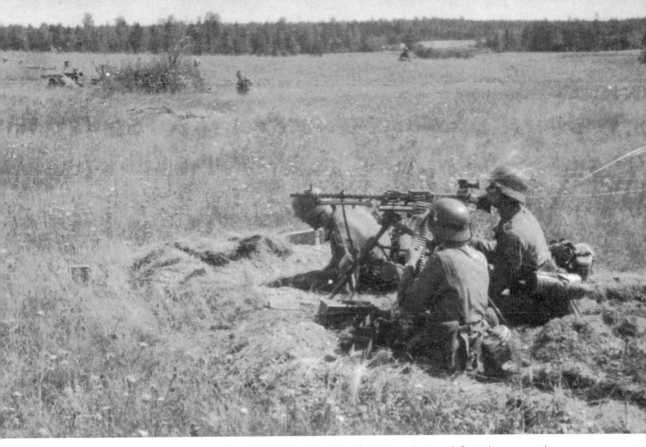

An MG34 machine gun crew out in a field during intensive fighting against undefeated enemy units. Although the Polish Army were dying a lingering death out on the battlefield, German infantry in a number of areas faced further battles with unsubdued enemy formations, determined to fight to the grim death.

A mortar crew in action against unsubdued enemy formations. In some areas the fighting was so bitter that German infantry made very little headway in their drastic attempt to force the Poles to surrender.

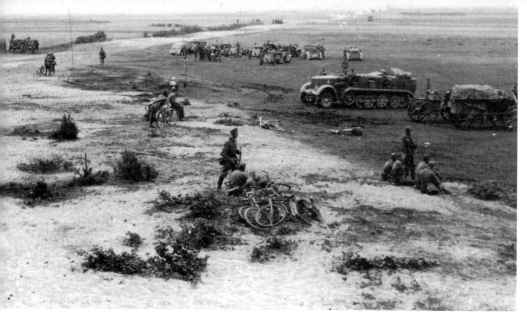

West of Warsaw showing a variety of vehicles halted in a field. Note the PaK35/36 anti-tank guns being towed by light Horch Cross-country vehicles. Due to the serious lack of vehicles available to the German Army in Poland a mixture of cars and lorries were utilised to tow supplies and light weapons, such as the PaK35/36.

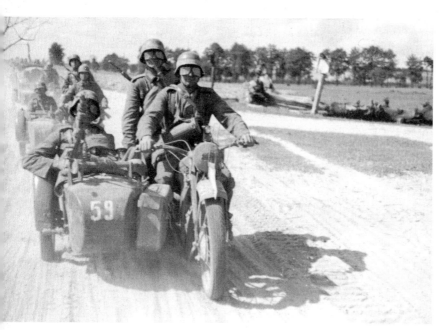

Three motorcycle combinations advance along a dusty road. The leading motorcycle has an MG34 mounted to the sidecar. During the Polish campaign motorcyclists generally rode into battle and dismounted to fight.

An interesting photograph showing a group of dismounted motorcyclists on a road somewhere in Poland during the later stages of the campaign. One of the motorcyclists can be seen scouring the sky through a pair of binoculars.

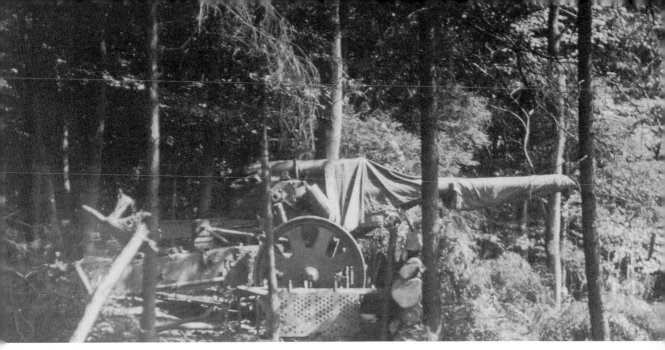

A 15cm howitzer hidden at the edge of some woodland. With the use of foliage and logs, the guns distinctive wheels have been more or less concealed. For additional camouflage canvas sheeting has been draped over the gun barrel.

A typical scene during the invasion of Poland. Here the gun carriage of a 15cm howitzer is being hauled by animal draught through some woodland. The weight of these artillery pieces and the way in which they were towed and positioned in the field proved that more tracked vehicles were needed.

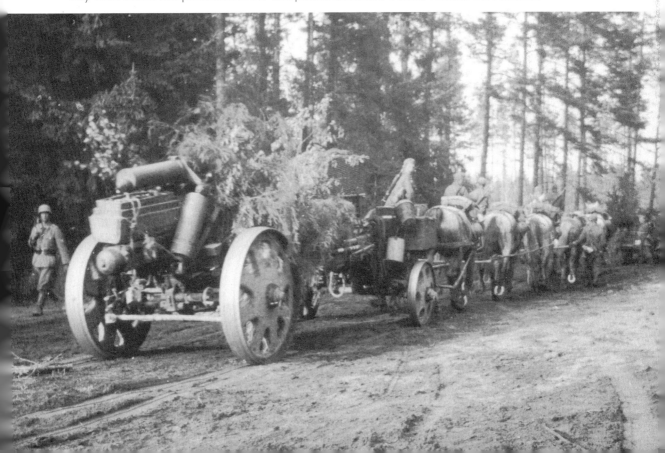

A halftrack hurtles through some woodland. It was soon found in Poland that the performance of the infantry attributed greatly to the use of halftracks transporting them onto the battlefield. By 1940 motorised infantry were used in France, where soldiers travelled by motor vehicle rather than on foot.

A well concealed PaK35/36 anti-tank gun inside a forest. The gun had proved its worth against Polish armour and was an essential ingredient in combating what little enemy resistance there was.

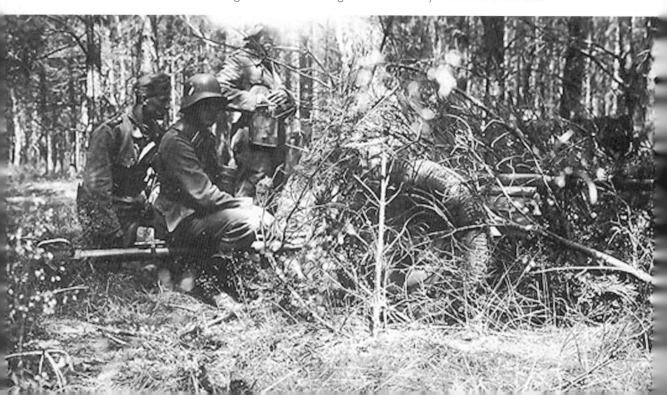

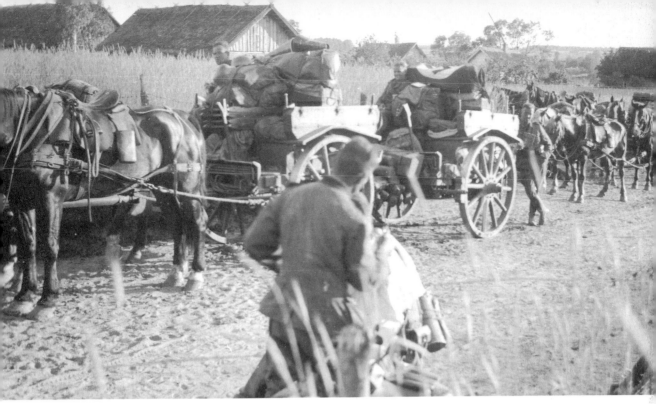

Well supplied Horse drawn infantry have halted on a road. During the second week of the campaign enemy resistance was cracking, and as a result there were many wholesale surrenders.

Infantry confer standing next to a building on what appears to be a farmstead. All the soldiers wear the standard army uniform of the period, an M35 steel helmet and M36 field blouse with its distinctive dark-green facing collar.

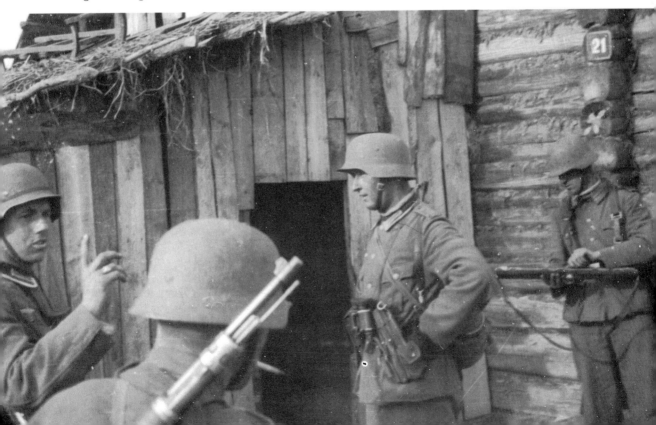

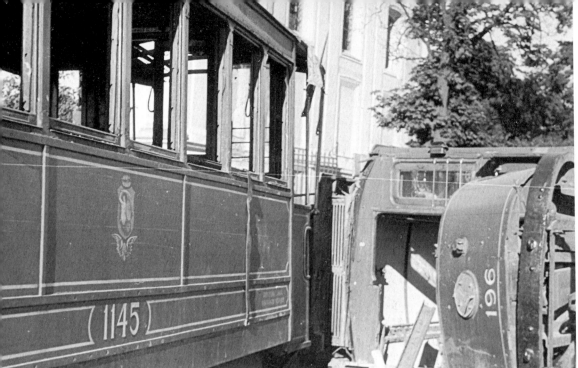

Inside the ravaged city of Warsaw the Poles used a variety of barricades in order to try and defend the streets of the capital from the attacking enemy. Here in this photograph trams have been used to block a route into the heart of the city. Courtesy of Jim Payne

Inside the suburbs of Warsaw an infantryman poses for the camera with artillery shells packed in wicker cases. On 25 September 1939 German artillery crews were ordered to step up their bombardments, and if need be reduce every road to rubble. Courtesy of Jim Payne

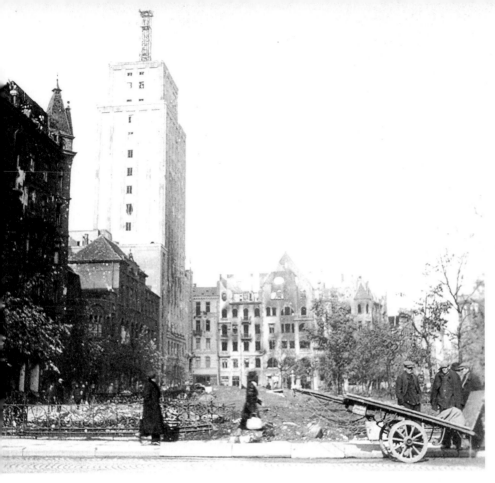

For weeks the inhabitants of Warsaw had to endure both heavy ground and aerial bombardments, often resulting in the deaths of many hundreds of civilians. Despite the fact that there was no running water, electricity, and food stocks critically low, the Poles tried their best to maintain a relatively normal existence in the rubble strewn streets.

German infantry belonging to Blaskowitz Eighth Army can be seen next to a statue on the Vistula River following the final surrender of Warsaw on 27 September. A total of 140,000 Polish troops defending the capital laid down their arms, including some 16,000 wounded.

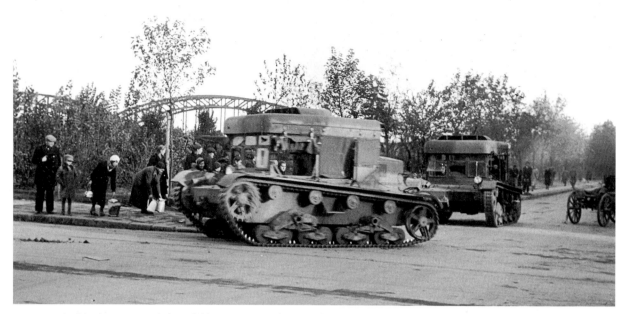

Inside the captured city of Warsaw two antiquated Polish armoured vehicles move along a road near the Vistula. These armoured vehicles were no match even against the light under gunned Pz.Kpfw.I.

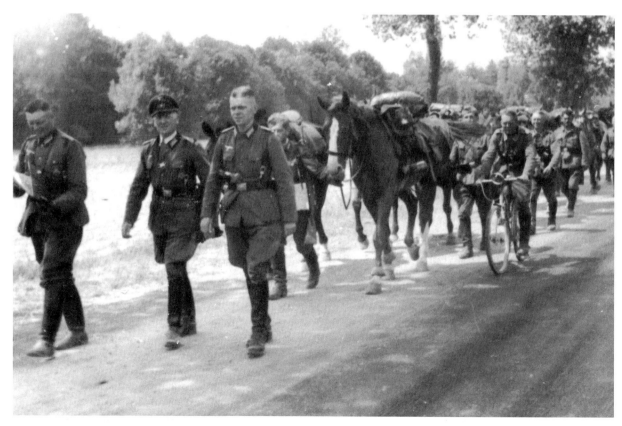

In the warm weather baptized, *Führer* weather, the troops march mainly on foot with their horses led by three officers. In spite a victorious march through Poland, there were area where the Germans faced a number of fierce isolated pockets of resistance.

A German soldier intent on capturing the aftermath of the battle for Warsaw stands in a car and photographs the devastation that surrounds him. Courtesy of Jim Payne

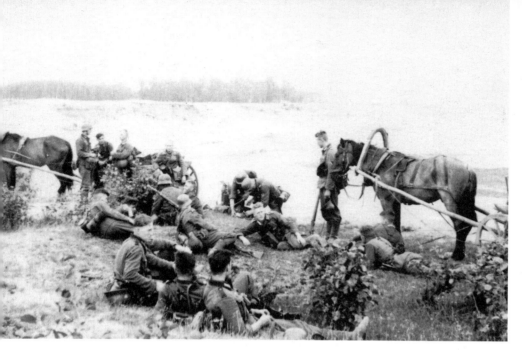

The long distances in which the German infantry marched were very exhausting for both man and horse. In this photograph soldiers rest in a field after enduring more than eighteen days of almost continuous foot marches and fighting. It would not be until the heartlands of Russia when fatigue would grip the infantry once again in the East.

German forces in an occupied town near Warsaw. Following almost three weeks of battle the Wehrmacht had occupied much of Poland. The very speed of the advance had undermined the will of many of the Polish units to fight on.

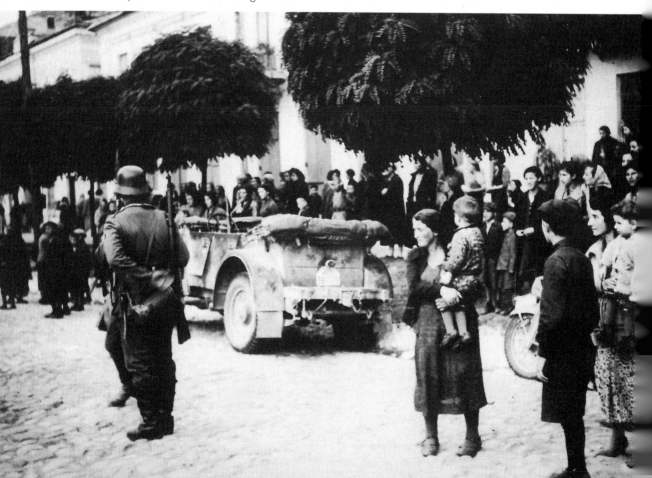

A German column of infantry advance through the decimated suburbs of Warsaw following its capitulation on 27 September 1939. A total of 140,000 Polish troops laid down their arms, including some 16,000 wounded.

On 5 October Hitler visited the captured capital and reviewed a triumphant march-pass by German infantry. The victory parade symbolised the might of the German Army and its conquest over Poland in little more than a month. They had won their battle against Poland by implementing a series of overwhelming, rapid penetrations. These penetrations were followed by the encirclement of an enemy that, in contrast to its German counterparts, was bound by static and inflexible defensive tactics.

German Order of Battle
September 1939

Army Group North

Army Group North
General Fedor von Bock. Objectives: Capture the 'Polish corridor' (4th and drive southwards towards Warsaw from East Prussia (3rd Army)

Army Group Reserve Troops
10th Panzer Division – General Ferdinand Schaal
4th Panzer Brigade
10th Motorised Rifle Brigade
73rd Infantry Division – General Friedrich von Rabenau
170th, 186th, and 213th Infantry Regiments
206th Infantry Division – General Hugo Höfl
301st, 312th, and 413rd Infantry Regiments
208th Infantry Division – General Moritz Andreas
309th, 337th, and 338th Infantry Regiments

4th Army
General Günther von Kluge. Headquarters Western Pomerania

4th Army Reserves
23rd Infantry Division – General Walter Graf von Brockdorff-Ahlefeldt
9th, 67th, and 68th Infantry Regiments
218th Infantry Division – General Woldemar Freiherr Grote
323rd, 386th, and 397th Infantry Regiments

Frontier Guard Command
207th Infantry Division – General Karl von Tiedemann
322nd, 368th, and 374th Infantry Regiments

XIX Corps - General Heinz Guderian
3rd Panzer Division – General Leo Freiherr Geyr von Schweppenburg
3rd Panzer Brigade and 3rd Motorized Rifle Brigade
2nd Motorized Division – Commanded by General Paul Bader
5th, 25th, and 92nd Motorised Infantry Regiments
20th Motorized Division – Commanded by General Mauritz von Wiktorin
69th, 76th and 80th Motorised Infantry Regiments
Panzer Lehr Battalion
Reconnaissance Demonstration Battalion

II Corps - General Adolf Strauß
3rd Infantry Division – General Walter Lichel
8th, 29th, and 50th Infantry Regiments.
32nd Infantry Division – General Franz Böhme
4th, 94th, and 96th Infantry Regiments

III Corps – General Curt Haase
50th Infantry Division – General Konrad Sorsche
121st, 122nd, and 123rd Infantry Regiments
'Netze' Infantry Brigade – General Eccard Freiherr von Gablenz

3rd Army
General Georg von Kuckler. Headqaurters in East Prussia

3rd Army Reserves
1st Cavalry Brigade – Commanded by General Kurt Feldt.
217th Infantry Division – General Richard Baltzer
311th, 346th, and 389th Infantry Regiments.

XXVI Corps
1st Motorised Division

XXI Corps – General Nikolaus von Falkenhorst
21st Infantry Division – General Hans-Kuno von Both

3rd, 24th, and 45th Infantry Regiments
228th Infantry Division – General Hans Suttner
325th, 356th, and 400th Infantry Regiments

I Corps – General Walter Petzel
Panzer-Division *Kempf* – General Werner Kempf
7th Panzer Regiment, and the 'Großdeutschland' Motorised Infantry Regiment
11th Infantry Division – Commanded by General Max Bock
2nd, 23rd, and 44th Infantry Regiments
61st Infantry – Commanded by General Siegfried Hänicke
151st, 162nd, and 176th Infantry Regiments

'Wodrig' Corps – Commanded by General Albert Wodrig [Later renamed XXVI
 Corps]
1st Infantry Division – General Joachim von Kortzfleisch
22nd, and 43rd Infantry Regiment
12th Infantry Division – General Ludwig von der Leyen
27th, 48th, and 89th Infantry Regiments

'Brand' Corps – Commanded by General Fritz Brand
'Lötzen' Infantry Brigade – General Offenbacher
161st and 162nd Landwehr Infantry Regiments
'Goldap' Infantry Brigade – Commanded by General Notle

Army Group South

Army Group South
Colonel General Gerd von Rundstedt: Objectives to spearhead 8th and 10th armies
from Silesia towards Warsaw and for the 14th army to smash the Polish forces
around Krakow.

Army Group Reserve Troops
62nd Infantry Division – General Walter Keiner
164th, 183rd, and 190th Infantry Regiments
213th Infantry Division – General Rene de l'Homme de Courbiere
318th, 354th, and 406th Infantry Regiments

221st Infantry Division – General Johann Pflugbeil
350th, 360th, and 375th Infantry Regiments

VII Corps – General Eugen Ritter von Schobert
27th Infantry Division – General Friedrich Bergmann
40th, 63rd, and 91st Infantry Regiments
68th Infantry Division – General Georg Braun
169th, 188th, and 196th Infantry Regiments
1st Mountain [Gebirgsjäger] Division – General Ludwig Kübler
98th, 99th, and 100th Mountain Jäger Regiments

8th Army
General Johannes Blaskowitz. Headquarters in northern Silesia

X Corps – General Wilhelm Ulex
24th Infantry Division – General Friedrich Olbricht
31st, 32nd, and 102nd Infantry Regiments
30th Infantry Division – General Kurt von Briesen
6th, 26th, and 46th Infantry Regiments

XIII Corps – General Maximilian Reichsfreiherr von Weichs
10th Infantry Division – Commanded by General Conrad von Cochenhausen
20th, 41st, and 85th Infantry Regiments
17th Infantry Division – General Herbert Loch. Consisted of the 21st, 55th, and 95th
 Infantry Regiments
SS-Division (mot.) *Leibstandarte SS Adolf Hitler* Motorized Infantry Regiment – Josef
 'Sepp' Dietrich

10th Army

General Walter von Reichenau. Headquarters in southern Silesia

10th Army Reserves
1st Light Division – General Friedrich-Wilhelm von Löper
11th Panzer Regiment and 6th Rifle Brigade
3rd Light Division – General Adolf Kuntzen
10th Panzer Regiment and 8th Rifle Brigade

XI Corps – General Emil Leeb

18th Infantry Division – General Friedrich-Karl Cranz
30th, 51st, and 54th Infantry Regiments
19th Infantry Division - General Günther Schwantes
59th, 73rd, and 74th Infantry Regiments

XVI Corps – General Erich Höpner
1st Panzer-Division – General Rudolf Schmidt
1st Panzer Brigade and 1st Motorized Rifle Brigade
14th Infantry Division – General Peter Weyer
11th, 53rd, and 116th Infantry Regiments
31st Infantry Division – General Rudolf Kämpfe
12th, 17th, and 82nd Infantry Regiments

IV Corps – General Viktor von Schwedler
4th Infantry Division – General Eric Hansen
10th, 52nd, and 103rd Infantry Regiments
46th Infantry Division – General Paul von Hase
42nd, 72nd, and 97th Infantry Regiments

XV Corps – General Hermann Hoth
2nd Light Division - General Georg Stumme
25th Panzer Regiment and 7th Rifle Brigade

XIV Corps – General Gustav von Wietersheim
4th Panzer Division - General Georg-Hans Reinhardt
7th Panzer Brigade and 4th Motorized Rifle Brigade.
13th Motorized Division - General Moritz von Faber du Faur
33rd, 66th, and 93rd Motorized Infantry Regiments
29th Motorized Division - General Joachim Lemelsen
15th, 86th, and 71st Motorized Infantry Regiments

14th Army
Colonel General Wilhelm List. Headquarters in Moravia and Slovakia

XXII Corps – General Ewald von Kleist
2nd Mountain Division – Commanded by General Valentin Feurstein
136th, 137th, and 140th Mountain Jäger Regiments

VIII Corps – Commanded by General Ernst Busch

5th Panzer Division – General Heinrich von Viettinghoff-Scheel
8th Panzer Brigade and 5th Motorised Rifle Brigade
8th Infantry Division – General Rudolf Koch-Erpach
28th, 38th, and 84th Infantry Regiments.
28th Infantry Division – General Hans von Obstfelder
7th, 49th, and 83rd Infantry Regiments.
239th Infantry Division – General Ferdinand Neuling
444th Infantry Regiments
SS 'Germania' Motorised Infantry Regiment – General Karl-Maria Demelhuber

XVII Corps – General Werner Kienitz
7th Infantry Division – General Eugen Ott
19th, 61st, and 62nd Infantry Regiments.
44th Infantry Division – General Albrecht Schubert
131st, 132nd, and 134th Infantry Regiments
45th Infantry Division – General Friedrich Materna
130th, 133rd, and 135th Infantry Regiments

XVIII Corps – Commanded by General Eugen Beyer
2nd Panzer-Division – General Rudolf Veiel
2nd Panzer Brigade and 2nd Motorised Rifle Brigade
4th Light Division – Dr. Alfred Ritter von Hubicki
33rd Panzer Regiment and 9th Rifle Brigade
3rd Mountain Division – General Eduard Dietl
138th and 139th Mountain Jäger Regiments

Luftwaffe
1st Air Fleet – Supporting Army Group North
4th Air Fleet – Supporting Army Group South

Kriegsmarine – *Navy Group East*
Battleship 'Schleswig-Holstein'
Battleship 'Schlesien'

Personal Equipment & Weapons

The German soldier was very well equipped and in 1939, when the German war was unleashed against Europe, they were perhaps the best in the world. The rifleman or *Schütze* wore the trademark model 1935 steel helmet, which provided ample protection whilst marching to the battlefront and during combat. His leather belt with support straps carried two sets of three ammunition pouches for a total of 60 rounds for his carbine. The soldier also wore his combat harness for his mess kit and special camouflage rain cape or *Zeltbahn*. He also wore an entrenching tool, and attached to the entrenching tool carrier was the bayonet, a bread bag for rations, gas mask canister, which was invariably slung over the wearer's shoulder and an anti-gas cape in its pouch, attached to the shoulder strap. The infantryman's flashlight was normally attached to the tunic and inside the tunic pocket he carried wound dressings. A small backpack was issued to the soldiers, though some did not wear them. The backpack was intended for spare clothing, personal items, and additional rations along with a spare clothing satchel.

The weapons used by the German soldier against Poland varied, but the standard issue piece of equipment was the 7.92mm Kar98k carbine. This excellent modern and effective bolt-action rifle was of Mauser design. This rifle remained the most popular weapon used by the German Army throughout the war. Another weapon used by the German Army, but not to the extent used by the Kar98k, was the 9mm MP38 machine pistol. This sub-machine gun was undoubtedly one of the most effective weapons ever produced for the German war machine. The 7.92mm MG34 light machine gun was yet another weapon that featured heavily within the ranks of the German Army. The effectiveness of the weapon made it the most superior machine gun ever produced at that time. The MG34 was a very impressive fire rate and could dominate the battlefield both in defensive and offensive roles. The German Army possessed the MG34 in every rifle group, and machine gun crews were able to transport this relatively light weapon easily onto the battlefield by resting it over the shoulder. Yet another weapon, which was seen at both company and battalion

level on the battlefield, was the 5cm 1.GrW36 light mortar and 8cm s. GrW34 heavy mortar. Although they could both be an effective weapon when fired accurately the light and heavy mortar was far too heavy and too expensive to produce on a very large scale.

At regimental and divisional level the German Army possessed its own artillery in the form of 7.5cm 1.IG18, 10.5cm l.FH18, 15cm s. FH18, and 15cm s. IG33 infantry guns. Specially trained artillery crews used these guns and they were seen extensively in Poland. The 3.7cm PaK35/36 was another weapon that was very popular especially during the early years of the war.

Typical German Infantry Battalion

Battalion Headquarters (5 Officers, 27 men)
Communications Platoon (22 men)
Battalion Supply Train (32 men)

Machine Gun Company (5 Officers, 197 men)
Company HQ (1 Officer, 14 men)
Company Train (17 men)
Mortar Platoon (1 Officer, 61 men)
Three Machine Gun Platoons, each (1 Officer, 35 men)

Three Rifle Companies (4 Officers, 187 men)
Company HQ (1 Officer, 12 men)
Company Supply Train (24 men)
Antitank Rifle Section (7 men)
Three Rifle Platoons, each comprised of;
Platoon HQ (1 Officer, 5 men)
Light Mortar Section (3 men)
Four Rifle Squads, each comprised of 10 men
Total Strength of 861 all ranks (22 Officers and 839 men)